50 CONTEMPORARY ARTISTS
YOU SHOULD KNOW

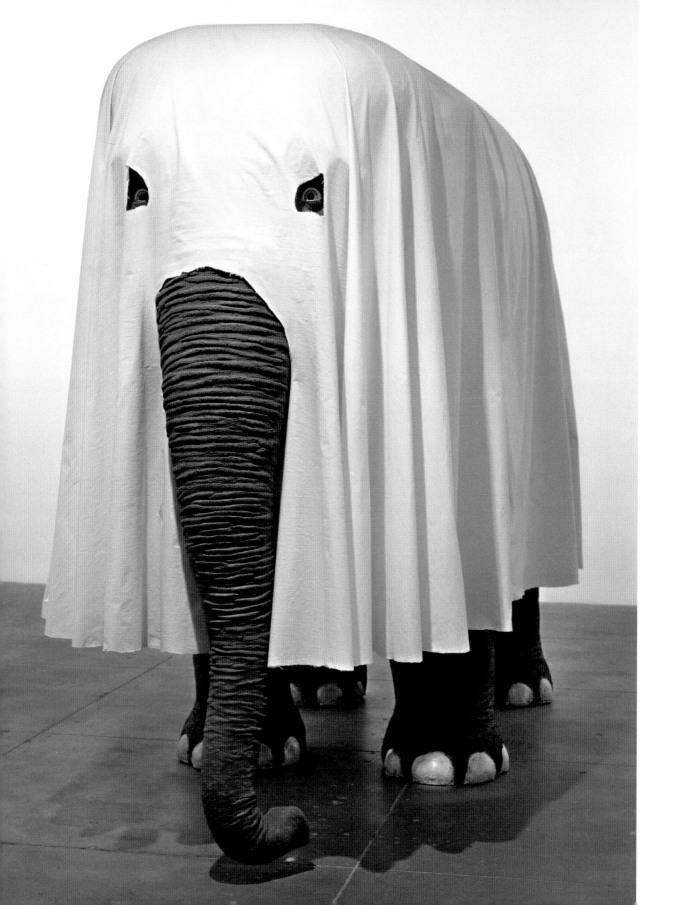

50 CONTEMPORARY ARTISTS
YOU SHOULD KNOW

Brad Finger
Christiane Weidemann

Prestel
Munich · London · New York

Front cover: Damien Hirst, *The Physical Impossibility of Death in the Mind of Someone Living*, see page 110
Frontispiece: Maurizio Cattelan, *Not Afraid of Love*, 2000, polyester styrene, resin, paint and fabric, 205.7 x 312.4 x 137.2 cm,
Courtesy of the artist and Marian Goodman Gallery, New York City
Pages 10/11: Mike Kelley, *Kandors*, installation view, Jablonka Gallery, Berlin 2007, Courtesy Gagosian Gallery, New York City

Prestel Verlag, Munich
A member of Verlagsgruppe
Random House GmbH

Prestel Verlag
Neumarkter Strasse 28
81673 Munich
Tel. +49 (0)89-4136-0
Fax +49 (0)89-4136-2335

Prestel Publishing Ltd.
14-17 Wells Street
London W1T 3PD
Tel. +44 (0)20 7323-5004
Fax +44 (0)20 7323-0271

Prestel Publishing
900 Broadway, Suite 603
New York, NY 10003
Tel. +1 (212) 995-2720
Fax +1 (212) 995-2733

www.prestel.de

www.prestel.com

Library of Congress Control Number is available; British Library Cataloguing-in-Publication Data: a catalogue record for this book is available from the British Library; Deutsche Nationalbibliothek holds a record of this publication in the Deutsche Nationalbibliografie; detailed bibliographical data can be found under: http://ww.dnb.de

Prestel books are available worldwide. Please contact your nearest bookseller or one of the above addresses for information concerning your local distributor.

Translated from the German by Paul Aston, Rome
Project management by Andrea Weißenbach
Copyedited by Jonathan Fox, Barcelona
Production by Astrid Wedemeyer
Cover and Design by LIQUID, Agentur für Gestaltung, Augsburg
Layout by zwischenschritt, Rainald Schwarz, Munich
Origination by ReproLine Mediateam
Printed and bound by Druckerei Uhl GmbH & Co. KG, Radolfzell
Paper: PrimaSet

Verlagsgruppe Random House FSC® N001967

Printed in Germany

FSC
www.fsc.org
MIX
Paper from
responsible sources
FSC® C004229

ISBN 978-3-7913-4530-7

CONTENTS

12 CY TWOMBLY

14 GERHARD RICHTER

18 DAVID HOCKNEY

20 BRUCE NAUMAN

22 ANSELM KIEFER

26 BARBARA KRUGER

28 PAUL MCCARTHY

30 JEFF WALL

34 RICHARD PRINCE

36 JENNY HOLZER

38 BILL VIOLA

42 MONA HATOUM

44 MARLENE DUMAS

48 NAN GOLDIN

50 SOPHIE CALLE

52 ANISH KAPOOR

56 ROBERT GOBER

58 MIKE KELLEY

60 CINDY SHERMAN

64 WILLIAM KENTRIDGE

68 JEFF KOONS

70 ANDREAS GURSKY

72 AI WEIWEI

74 SHIRIN NESHAT

78 PETER DOIG

80 NEO RAUCH

84 RAYMOND PETTIBON

86 MAURIZIO CATTELAN

90 TRACEY MOFFATT

92 TAKASHI MURAKAMI

94 PIPILOTTI RIST

96 GABRIEL OROZCO

100 TRACEY EMIN

102 RACHEL WHITEREAD

104 ZHANG HUAN

108 ELIZABETH PEYTON

110 DAMIEN HIRST

112 JAKE & DINOS CHAPMAN

116 OLAFUR ELIASSON

120 MARIKO MORI

122 SAM TAYLOR-WOOD

124 TAL R

128 MATTHEW BARNEY

132 WOLFGANG TILLMANS

134 CHRIS OFILI

136 DOUG AITKEN

140 GREGOR SCHNEIDER

142 KARA WALKER

146 ANSELM REYLE

150 JONATHAN MEESE

154 GLOSSARY

157 PHOTO CREDITS

157 INDEX

1929 Opening of the Museum of
Modern Art in New York

1941 Japanese attack
Pearl Harbor

1945 Beginning of the Cold War

1959 Allan Kaprow organizes the first happening
at the Reuben Gallery in New York

| 1920 | 1925 | 1930 | 1935 | 1940 | 1945 | 1950 | 1955 | 1960 | 1965 | 1970 |

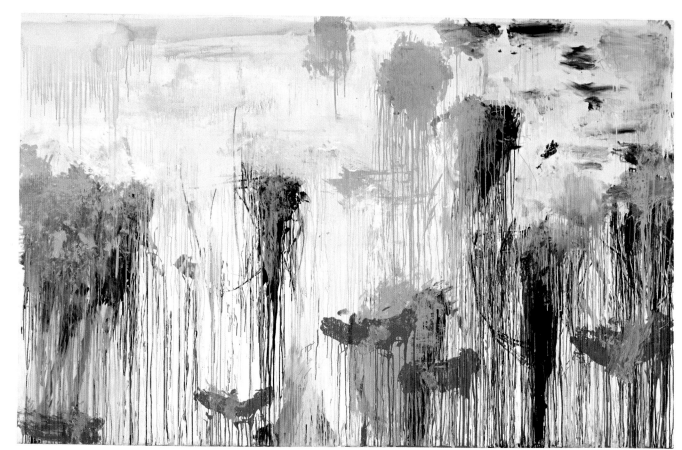

Cy Twombly, *Lepanto*, 2001, acrylic,
wax crayon and graphite on canvas,
217.2 x 340.4 cm, Courtesy Gagosian
Gallery, New York

CY TWOMBLY

A traditional saying claims that "a picture is worth a thousand words." Cy Twombly's art has explored the connections between writing and the painted image. Words become part of Twombly's creations—sometimes swirling around his canvases like thin brush strokes. These words often provide vital clues as to how the art should be understood.

The records of the past, both visual and written, have long inspired Edwin "Cy" Twombly. He showed an early talent for painting, studying at Black Mountain College in North Carolina—one of the first American colleges to hire major modern artists as faculty members. There Twombly experimented with abstract expressionism and other styles championed by his teachers. The young painter also spent time traveling to countries around the Mediterranean, absorbing their culture and ancient heritage. He even served a stint in the United States Army, working as a cryptologist—a decipherer of codes. Soon Twombly's art would incorporate his studies of the classical past and his talent for finding the hidden meaning in language.

By the mid-fifties, Twombly had begun to create paintings that looked like scribbles in a notebook or graffiti on a wall. Individual words or phrases would emerge on the canvas among a tangled web of lines. Sometimes these words, as seen in *Olympia* (1957) or *Arcadia* (1958), directly alluded to ancient history. Twombly's new art seemed to capture contradictory impulses in modern society. It reminded people of the continuing influence of classical stories and the written word. But it also suggested the chaotic and sometimes destructive elements of twentieth-century life.

Twombly moved to Rome in 1959 and established his permanent residence. There his art would undergo a series of subtle changes. During the early sixties, for example, Twombly's work became more colorful and complex, often integrating a potpourri of sensual shapes, words, phrases, and numbers. Such works as the *Ferragosto* series (1961) seemed to reflect the vibrant, culturally rich nature of his newly adopted home. Later in that decade, Twombly would simplify his style and color palette dramatically, focusing on white geometric shapes against dark backgrounds. An untitled work from 1969 featured bent, rectangular shapes that resembled fluttering pages. These shapes were interspersed among scrawled words and lettering, as if a text had become physically separated from its book.

Twombly also developed his own brand of abstract sculpture, often combining pieces of wood, plant materials, and other collected objects. He then painted or plastered the sculptures white, giving them a static, antique appearance. Some of his works directly evoked characters from classical mythology. One famous piece from 1978 incorporated an elegant, wing-like palm leaf. Twombly entitled this work *Cycnus*, after the son of Apollo who was turned from a hunter into a swan—a character symbolic of the renewal of life.

Later in his career, Twombly began producing large-scale works that harkened back to the tradition of historical painting. His multi-canvas *Lepanto* series (2001) vividly recalled the great sixteenth-century naval battle between forces of Catholic Europe and the Islamic Ottoman Empire. Ship-like forms are set alongside splashes of color that resemble cannon fire and soldiers' torches. Though originally prepared for the Venice Biennale, this work has come to remind some viewers of the contemporary, post-9/11 struggle between Islam and the West. *bf*

1928 Born in Lexington, Virginia
1948–49 Studies at Washington and Lee University in Lexington and at the School of the Museum of Fine Arts, Boston
1950–51 Studies at the Art Students League, New York
1953 First solo exhibition, at the Kootz Gallery, New York
1957 Settles in Rome
1994 Retrospective at the Museum of Modern Art, New York
2002 Takes part in group-exhibition *Art Chicago*, at the CAIS Gallery
2008 Awarded the Gerhard Altenbourg Prize
2011 Dies in Rome, Italy

Cy Twombly, May 2005

GERHARD RICHTER ▬▬▬

DANIEL SPOERRI ▬▬▬

SIGMAR POLKE ▬▬▬▬▬▬▬▬▬▬▬▬▬▬▬▬▬▬▬▬▬▬▬▬▬▬▬▬▬▬▬▬▬▬▬

1945 Auschwitz concentration camp
liberated on January 27th

1957 Soviet *Sputnik* launched

1966 Barnett Newman
paints *Who's Afraid of
Red, Yellow and Blue?*

1939–45 World War II

| 1920 | 1925 | 1930 | 1935 | 1940 | 1945 | 1950 | 1955 | 1960 | 1965 | 1970 |

Gerhard Richter, 19.4.07, 2007,
enamel on photograph, 16.9 x 12.5 cm,
Private collection

1977 German Autumn (Baader-Meinhof gang)

1986 Explosion destroys the US space shuttle *Challenger*

1999 Columbine High School massacre

2010 German director, author, and action artist Christoph Schlingensief dies in Berlin

2007 Al Gore awarded Nobel Peace Prize

1975 1980 1985 1990 1995 2000 2005 2010 2015 2020 2025

GERHARD RICHTER

"What shall I paint? How shall I paint? 'What' is the hardest thing because it is the essence. 'How' is easy by comparison. To start off with the 'How' is frivolous, but legitimate. Apply the 'How' and thus use the requirements of technique, the material and physical possibilities, in order to realize the intention. The intention: to invent nothing—no idea, no composition, no object, no form—and to receive everything: composition, object, form, idea, picture." Gerhard Richter, 1986

Gerhard Richter has been working in the traditional medium of painting for more than four decades, examining its importance in our modern, media-dominated society, and offering proof that, despite countless prophesies of its demise, it remains very much relevant. Richter was born in Dresden, East Germany in 1932, and after working as a scene painter and commercial artist, enrolled in the art academy there. In 1961, he fled to the West to escape the restrictive confines of the East's ideologically exploited art, and started all over again at the art academy in Düsseldorf.

Painted photography
In the early sixties, Richter discovered an artistic niche for himself by using trivial photographs as source material. "I had had enough of bloody painting, and painting from a photograph seemed to me the most moronic and inartistic thing that anyone could do," he explained in retrospect. He used personal snapshots for portraits and family scenes as well as images from the mass media, and by deliberately blurring the image while painting created a certain distance from the pictorial content. In his most recent overpainted and realistic photo-based works, Richter does not play painting and photography off one another. Rather the artist reveals that subjective perception is only scarcely related to the objective experience of reality, that pictures are "not what is represented, but its appearance."

Painting as an experiment
After his photorealistic works, beginning in 1966 came the first *Color Charts* based on paint sample cards; the monochrome *Gray Paintings*, in which Richter experimented with different ways of applying paint; and the colored *Inpaintings*, which were completely void of representation. He then moved on to a series of pastose landscape pictures, *Mountains* and *Townscapes*, as well as to the roman-ticized *Landscapes*, *Seascapes*, and *Clouds* for which he used highly transparent washes. Common to all of these series is the absence of people. In 1976, he put this new direction aside and started over again with abstract works, but painted without source images. These now make up the greater part of his output. The inherent effect of color and shape and the factor of chance play an important role in his creative process. Richter applies layer upon layer of paint to the canvas with "planned spontaneity," using spatulas, brushes, and squeegees; he removes the paint, and reapplies it until he considers the picture finished.

Gerhard Richter extensively explores the possibilities of the historic medium of paint, demonstrating his ability to change, and in large part works against the artistic conventions of any given time. "I pursue no objectives, no systems, no tendency, I have no program, no style, no direction," he remarks, and espouses an open-ended concept of a work of art. He is the only German artist to whom New York's MoMA—the preeminent institution of modern art—has devoted a major retrospective during his lifetime. *cw*

1932 Born in Dresden, Germany

1948–51 Works as a scene painter and commercial artist in Zittau in the German Democratic Republic

1952–56 Studies at the Art Academy in Dresden

1961–63 Member of the master class at the Düsseldorf Academy of Art

1967 Visiting lecturer at the College of Visual Art in Hamburg

1971–94 Art teacher in Düsseldorf

1972 Represented in the German Pavilion at the 36th Venice Biennale

1975–92 Member of the Academy of Art, Berlin

1982 Marries sculptor Isa Genzken

1988 Visiting lecturer at the State Academy of Fine Arts, Städel-schule, Frankfurt am Main

1997 Awarded the Praemium Imperiale Prize

2005 Founding of Gerhard Richter Archive in Dresden

2007 Takes part in Documenta 12, Kassel

Gerhard Richter, 2002

Gerhard Richter, *January*, 1989, oil on
canvas, diptych, 320 x 400 cm overall,
Saint Louis Art Museum

Gerhard Richter, *Cathedral Square, Milan*,
1968, oil on canvas, 275 x 190 cm,
Collection Park Hyatt, Chicago

DAVID HOCKNEY ══

JANNIS KOUNELLIS ══════════════════════════════════════

BRUCE NAUMAN ══

1940 First McDonald's restaurant opened

1962 Cuban missile crisis

1949 NATO founded

1920 1925 1930 1935 1940 1945 1950 1955 1960 1965 1970

David Hockney, *Bigger Trees Near Warter
Or/Ou Peinture Sur Le Motif Pour Le
Nouvel Age Post-Photographique*, 2007,
oil on canvas in 50 parts, 460 x 1220 cm
overall, Tate Gallery, London

DAVID HOCKNEY

Hockney remains one of Britain's most famous artists. His outgoing personality is often reflected in his iconic images—bright poolside scenes from California and colorful landscapes from Yorkshire, England. The artist's inquisitive nature has also enabled him to embrace new technology in his art.

David Hockney has always tried to stay a step ahead of cultural trends. Born in Bradford, England, he grew up in a United Kingdom recovering from the ravages of World War II. But the budding artist had little fear of his changing country. While studying at the Royal College of Art in London, he became open about his own homosexuality—a dangerous subject in the fifties. Such openness soon revealed itself in paintings like *We Two Boys Clinging Together* (1961). The embracing male figures revealed just how daring Hockney could be about gay life. Yet the image's title referenced a far earlier gay-themed creation, Walt Whitman's famous passage from the nineteenth-century poetry collection *Leaves of Grass*.

Hockney soon began to explore other parts of the world for inspiration. His most fruitful journeys took him to New York City, where he befriended Andy Warhol and other luminaries in the Pop Art movement, and to Southern California, where he found a laid back way of life that best suited his disposition. During his early years in Los Angeles, Hockney began to probe the city's contradictory nature. His use of newly developed acrylic paints gave his California images a bright sheen, perfectly capturing L.A.'s relentlessly sunny climate. Yet the images also suggest a pervasive feeling of loneliness and fractured sense of community. *A Bigger Splash* (1967), for example, shows a world perfectly created for human consumption. Yet the beautiful stage set is devoid of people and human interaction. Even the splash appears frozen in time, a permanent fixture of an empty land.

The disjointed nature of modern life became even more explicit in Hockney's photocollages, most of which he produced during the eighties. These works usually focused on a landscape or street view; and they were assembled from numerous, quickly taken Polaroids. The final products often resemble unfinished jigsaw puzzles. In *Merced River, Yosemite Valley* (1982), the Merced's sprawling boulders and churning rapids become even more chaotic within Hockney's skewed pictorial composition.

Like many visual artists, Hockney had a love of performance that led him to design stage sets and costumes for operas and plays. His designs for such productions as *Rake's Progress* in 1975 and *The Magic Flute* in 1978 had a wistful, almost paper-like quality. They seemed to suggest the ephemeral nature of theater as an art form.

As his career has progressed, Hockney has continued to incorporate new techniques—and new technology—into his art. He has used digital printers and fax machines to produce and transmit drawings. The artist has even begun creating sketches on an iPhone and iPad. These digital images resemble postcard versions of Hockney's more traditional art. Their subjects vary from landscapes to crayon-like texts against multicolored backgrounds. Hockney often sends these tiny works to friends, who in turn forward them to other recipients—suggesting new methods for the production and dissemination of art. Hockney's later career has also been devoted to commissions for grand, multi-panel paintings. These works include *Bigger Trees Near Water* (2007), and they show the artist's continuing love of bright, abstract color and his attention to realistic detail. They also reveal his growing interest in portraying the nation of his birth. *bf*

1937 Born in Bradford, England
1948 Wants to become an artist and shows his posters on school bulletin boards
1959 Studies art in London
1960 His pictures are shown in public for the first time
1963 Finally makes a name for himself; meets Andy Warhol.
1976 Travels across the United States
1980 His hearing declines
1982 Buys a house in Hollywood
1999 Three Hockney exhibitions open in Paris simultaneously
2001 Publication of his book *Secret Knowledge: Rediscovering the Lost Techniques of the Old Masters*
2007 *Hockney on Turner Watercolours* is shown at the Tate Modern, London

David Hockney, undated

1942 Peggy Guggenheim opens her Art of
this Century gallery in New York

1959 Alaska and Hawaii become
the 49th and 50th states

1950–53 Korean War

1920 1925 1930 1935 1940 1945 1950 1955 1960 1965 1970

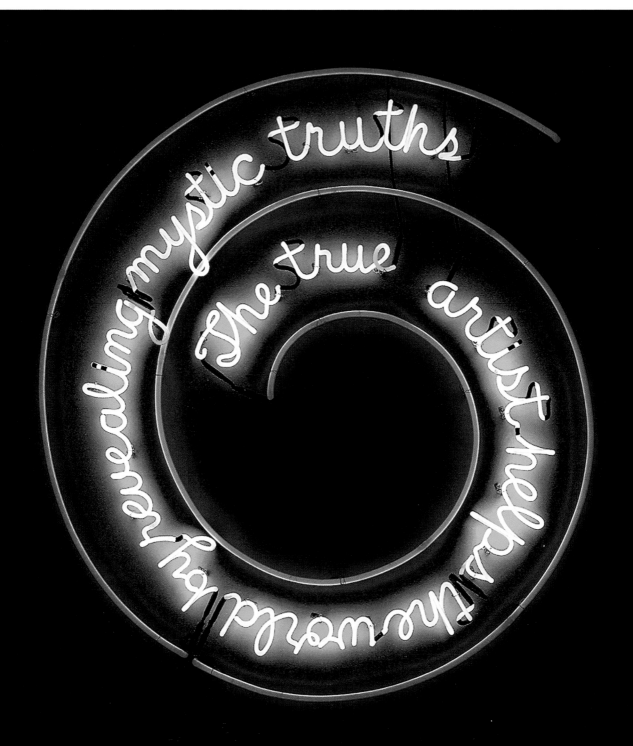

1971 First Starbucks opens **1981** Ronald Reagan sworn in as 40th US president **1994** Tutsi genocide in Rwanda **2007** Al Gore awarded Nobel Peace Prize

2000 Dot-com bubble bursts **2010** Disastrous oil leak in the Gulf of Mexico

1975 1980 1985 1990 1995 2000 2005 2010 2015 2020 2025

BRUCE NAUMAN

Bruce Nauman is an eclectic artist. He uses sculpture, drawing, video, found objects, and performance art to explore the power of language and symbols. He also continually experiments with the art-making process.

"In the studio ... I spend a lot of time looking and thinking," Bruce Nauman has said, "and then trying to find the most efficient way to get what I want, whether it's drawing or sculpture or casting plaster or whatever." For Nauman, process is "part of the enjoyment." By creating new working methods for different projects, he is able to produce the "surprising" results that keep his art fresh.

Nauman's creations often directly incorporate the element of surprise. From his early years as an artist, he explored the potential of using his own body in his work. In a series of performance-art films called *Art Make-Up* (1967–68), Nauman was shown covering his face and torso with different-colored paints. Here the artist made a "performance" out of the simple act of disguising himself—an act that often left viewers thinking about what they did not get from the performer. The work's title also revealed Nauman's love of double entendres, referring not only to the makeup itself but also to the creation of art from scratch. Other Nauman performance works were captured in famous screenprints. In *Studies for Holograms* (1970), the artist was shown manipulating his own facial features. The prints had a washed-out appearance, emphasizing the shapes the artist could make with his lips and neck. Nauman saw these works as a way of crystallizing "arbitrary" actions, actions that could affect different viewers in different ways.

Nauman used other means of examining permanence and impermanence. He made bronze casts of detached hands, placing them on thin tables or hanging them from the ceiling on wires. The "floating" limbs spread across the exhibit room, their gestures reminiscent of the fleeting movements of dancers. Other cast sculptures were made from dead animals—often horses or fish. In *One Hundred Fish Fountain* (2005), Nauman featured a suspended "school" of ninety-seven bronze fish connected by tubes. At regular intervals, water ran through the tubes and squirted out of the fishes'

bodies. The combination of tubes, fish, and liquid seemed to symbolize nature on "life support"—and the human-induced "draining" of natural habitats. Yet Nauman has also spoken about childhood fishing trips that inspired this work, comments that may link the piece to themes surrounding human memory and dislocation.

Some of Nauman's best-known works play games with language and commercialism. In the late sixties, he began making art out of neon tubing. These pieces evoked advertising signs that dotted the American landscape, from rural diners to big-city movie palaces. In *The True Artist helps the World by Revealing Mystic Truths* (1967), Nauman twisted the banal language of advertising to make a "pitch" for the artist in society. Even the form of the fake sign was twisted, with all of its wires exposed and its words set in a spiral shape. In *Human/Need/Desire* (1983), the artist's neon words flashed on and off—suggesting conflicts between the disposable urges of American commerce and the more permanent demands of human society.

Today, Nauman continues to explore new media and working methods. In 2000, he created a long outdoor stairway in hilly northern California. The stairway's steps are irregular and often steep, forcing people to think about each step as an individual action—a metaphor for the individuality that Nauman brings to all of his artworks. *bf*

1941 Born in Fort Wayne, Indiana
1960–64 Studies mathematics and physics at the University of Wisconsin-Madison
1964–66 Studies art at the University of California
1968 Takes part in Documenta 4
1990 Awarded the Max Beckmann Prize
1999 Awarded the Golden Lion for Lifetime Achievement at the 48th Venice Biennale
IN 2004 Creates his work *Raw Materials* specifically for display at the Tate Modern

left page
Bruce Nauman, *The True Artist Helps the World by Revealing Mystic Truths (Window or Wall Sign)*, 1967, neon tubing with clear glass tubing, 149.9 x 139.7 x 5.1 cm, Philadelphia Museum of Art: Purchased with the Henry P. McIlhenny Fund, the bequest (by exchange) of Henrietta Meyers Miller, the gift (by exchange) of Philip L. Goodwin, and contributions from generous donors, 2007, Courtesy Sperone Westwater, New York

above
Bruce Nauman, *Hologram B from First Hologram Series: Making Faces (A-K)*, 1968, holographic image on glass, 20.3 x 25.4 cm. Courtesy Sperone Westwater, New York

1954 First commercial nuclear power
plant in Obninsk near Moscow

1965 Joseph Beuys action
*How to Explain Pictures
to a Dead Hare*

1945 Auschwitz concentration camp
liberated on January 27th

1961 Berlin Wall constructed

1920 1925 1930 1935 1940 1945 1950 1955 1960 1965 1970

Anselm Kiefer, *Das Sonnenschiff*, 2010,
plaster, aluminum, resin, plaster sun
flowers, 190 x 460 x 290 cm

2007 German painter Jörg Immendorff
dies in Düsseldorf

1976 First G7 summit

1988 Freeze exhibition in London launches
Young British Artists

2010 Largest art heist in history at the
Museum of Modern Art in Paris

2004-9 Construction of the Burj Dubai

1975 1980 1985 1990 1995 2000 2005 2010 2015 2020 2025

ANSELM KIEFER

Perhaps more than any other contemporary artist, Anselm Kiefer has made the ideological history of German culture the subject of his work. "I tell stories in my pictures," he explains, "to show what's behind the story. I make a hole and go through." His photo series Besetzungen *(Occupations), for which he had himself photographed making the Fascist salute, made him one of the best-known if most controversial contemporary German artists.*

Anselm Kiefer, born in 1945 in Donaueschingen, takes a critical look at German history in a great deal of his work. Kiefer was one of the first artists to reflect on the Nazi appropriation of myths and legends and to point out their unbroken power, so that they can not, he says, "get in through the back door and wreak destruction." According to the citation for the Peace Prize awarded to him by the German Book Trade in 2008 (the first time it has been given to a visual artist), he "appeared at an ideal moment in history to transcend the post-war dictate of non-committal and non-concrete representation." In 1969, things looked quite different. The public and art critics alike reacted with horror to his *Besetzungen* series. Traveling through various countries in Europe, Kiefer slipped into the role of a Fascist to have his photo taken making the Hitler salute against a backdrop of different cultural sites such as the Roman Coliseum. He wanted to "reenact what they did just a little bit in order to understand the madness." He admitted: "I very much felt the fascination that made it possible for the majority of Germans to temporarily believe in it."

World history as "material"
Anselm Kiefer turned to art after studying law and Romance languages. He went to art colleges in Freiburg and Karlsruhe, and had contact with Joseph Beuys at the state art academy in Düsseldorf. His works can hardly be compared to the those of any of his German painter contemporaries. He created landscapes on monumental canvases in earthy tones, and combined oil, acrylic and shellac with diverse materials such as gold, clay, wood, fabric, straw, barbed wire, and lead. Handwritten names and terms make reference to German history and Nazism. Kiefer subsequently turned apocalyptic; he attacked his canvases with an axe or retouched them with a blowtorch to give the pictures a desolate air. The works appear enigmatic in their aesthetic obsession, and leave the viewer with a

series of open questions in relation to his engagement with history. His 1980 exhibition at the 39th Venice Biennale, *Verbrennen, Verholzen, Versenken, Versanden*, set off contentious political debate about the artist's objectives.

In the nineties, Kiefer moved away from modern German history in order to take up more universal subject matters, dealing with philosophy, religion and mysticism, literature and poetry. In addition to the painting that holds a special place in his oeuvre, his work includes photographs and artist books, sculptures, woodcuts, installations, and glass vitrines. Kiefer has won numerous awards, including the International Prize of the jury at the 47th Venice Biennale and the Japanese Praemium Imperiale in 1999. *cw*

1945 Born in Donaueschingen,
Germany
1966–68 Studies painting in Freiburg
1969–70 Studies at the Karlsruhe Art
Academy
1999 Awarded the Praemium Imperiale
Prize
2007 Commissioned to create a work
for the Louvre in Paris
2008 Awarded the German Book
Trade's Peace Prize

Anselm Kiefer, undated

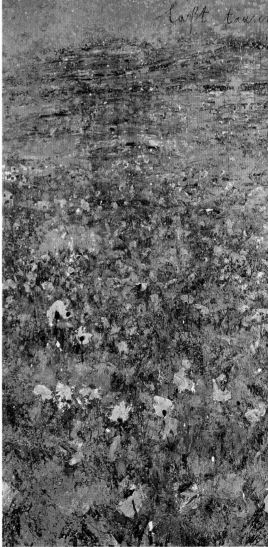

above
Anselm Kiefer, *Occupations (Sea)*, 1969,
8 photographs on cardboard, 80 x 117 cm

right
Anselm Kiefer, *Lasst tausend Blumen
blühen*, 2000, oil, shellac and emulsion
on canvas, 280 x 500 cm

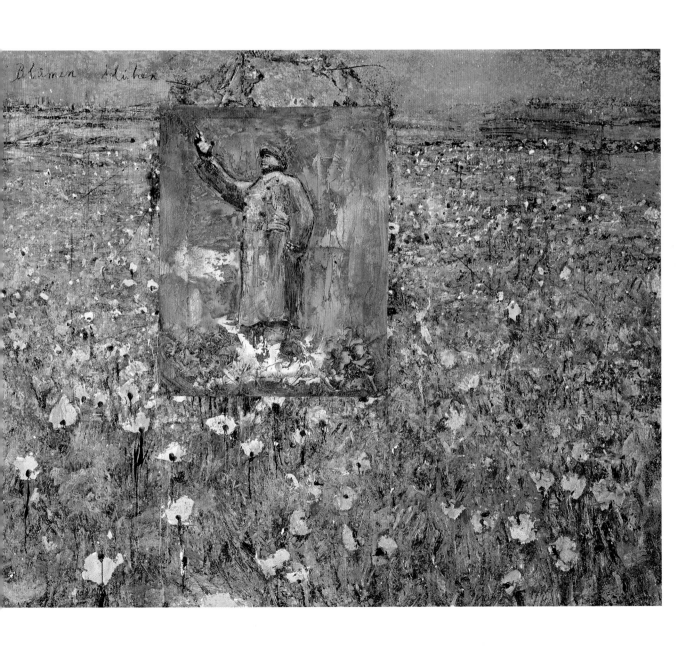

1945 US drops atomic bombs on Hiroshima and Nagasaki

1955 *The Family of Man* exhibition at the Museum of Modern Art in New York

1962 Andy Warhol paints *Campbell's Soup Cans*

1969 Woodstock Festival in upstate New York

1920 1925 1930 1935 1940 1945 1950 1955 1960 1965 1970

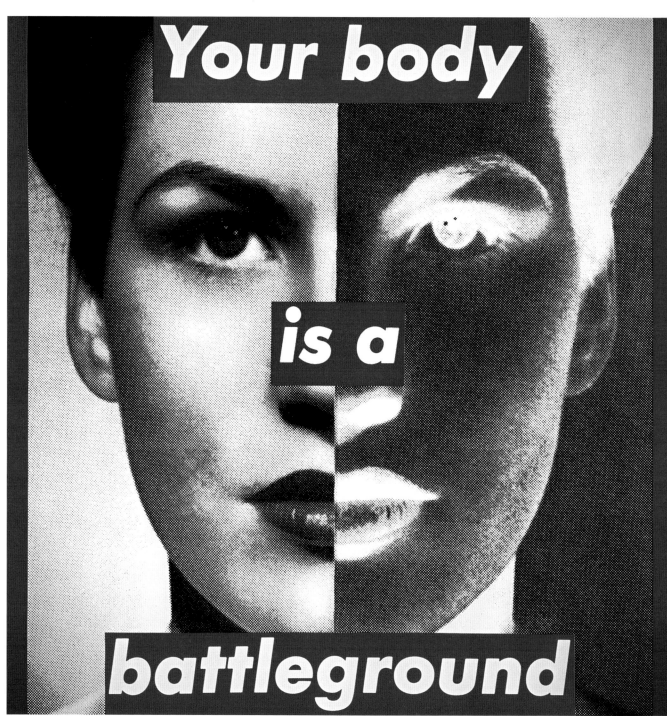

1983 Discovery of the
AIDS virus, HIV

1991 World Wide Web (WWW) cleared
for general use

2009 Barack Obama awarded
Nobel Peace Prize

2005 Hurricane Katrina devastates New Orleans

1998 Lewinsky affair makes
the headlines

1975 1980 1985 1990 1995 2000 2005 2010 2015 2020 2025

BARBARA KRUGER

Barbara Kruger's collage-like works appear in a style as consistent as corporate design: combative messages leap out at us, written in contrasted black, white, and red Futura Bold Italic against a background of grainy photographs. "I try to deal with the complexities of power and social life," explains Kruger, "but as far as the visual presentation goes I purposely avoid a high degree of difficulty. I want people to be drawn into the space of the work."

Barbara Kruger launched her work in the eighties with nighttime campaigns plastering denunciatory text-based posters around the center of New York. Having become one of the most prominent international conceptual artists, her pithy combinations of picture and text are instantly recognized when they appear unexpectedly amidst the glut of visual and textual messages in our urban environments.

media, she successfully adopts their methods and subverts them. Her collages, objects, and film/audio installations have been acquired for major collections such as the Tate Gallery, the Guggenheim Museum, and the MoMA. In 2005, Barbara Kruger was awarded the Golden Lion for Lifetime Achievement at the 51st Venice Biennale. She lives in New York and Los Angeles. *cw*

Verbal assaults

Taken in by viewers often in just a fraction of a second, the messages are intended to resonate in the mind; behind apparently familiar turns of phrase lies subject matter of a complex nature. In 1989, Kruger wrote "Your body is a battleground" across the portrait of a woman in order to call attention to a major demonstration in Washington, DC, in defense of the right to abortion. The poster made history, and was adopted in many other countries in the fight for women's rights.

Kruger's works confront viewers with their own principles and expectations, which are ultimately an expression of cultural norms. In one of her best-known works, a hand holds a white sign that reads in large red letters, "I shop therefore I am": if you buy a lot, you're worth a lot; buying is living. Based on the Cartesian dictum *cogito, ergo sum* (I think, therefore I am), the formula parodies the mindset of the consumer society. Still another work comments on the ideal image of woman reflected in the media: "Super rich/Ultra gorgeous/Extra skinny/Forever young" is written over the image of a stereotypical model's face recovering from plastic surgery.

Barbara Kruger studied at Syracuse University and the Parsons School of Design in New York. However, she says the greatest influence on her work was her practical experience. For years, she labored in important positions as a graphic designer, photo editor, and art director for magazines such as *Vogue* and *Mademoiselle*. Familiar with the aesthetic and linguistic strategies of advertising and

1945 Born in Newark, New Jersey
1964 Becomes an art student at Syracuse University, and from 1965 attends courses at the Parsons School of Design
1974 Holds her first solo show in New York
1975 Takes teaching posts at universities and art institutions in the US
1980 First solo exhibition at P.S. 1, Long Island City, New York
2005 Awarded the Golden Lion for Lifetime Achievement at the 51st Venice Biennale

left page
Barbara Kruger, *Untitled (Your Body is a Battleground)*, 1989, collage (photographic silkscreen/vinyl), 284.5 x 284.5 cm, The Broad Art Foundation, Santa Monica, California, Courtesy Mary Boone Gallery, New York

above
Barbara Kruger, undated

1945 Marilyn Monroe discovered
as a photo model

1956–59 Guggenheim Museum con-
structed in New York

1968 Assassination
of Martin
Luther King

1920　1925　1930　1935　1940　1945　1950　1955　1960　1965　1970

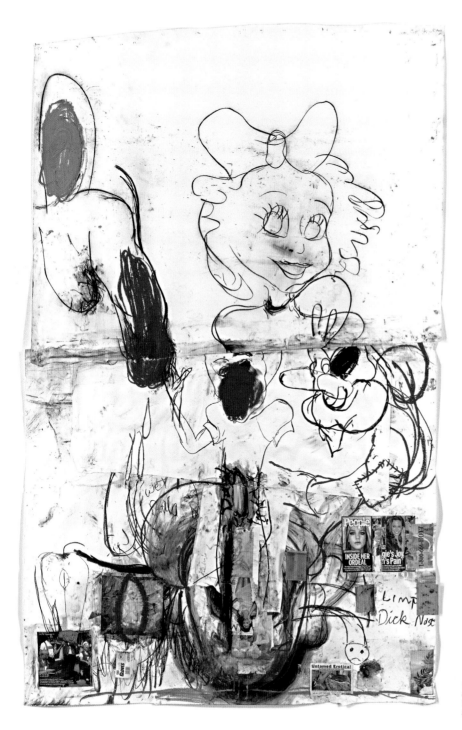

Paul McCarthy, *Inside Her Ordeal*, 2009, oil stick,
charcoal and collage on paper, 322.6 x 205.7 cm,
Friedrich Christian Flick Collection, Courtesy the
artist and Hauser & Wirth

PAUL MCCARTHY

McCarthy revels in the messiness of human existence. His sculptures, drawings, and installations often feature excrement and other messy bodily functions. They also parody iconic figures in popular culture, especially those with a "pristine" reputation.

For Paul McCarthy, the body is a primary tool for making art and a primary means for exploring ideas. The artist studied filmmaking at the University of Southern California, a school with close ties to the Hollywood movie industry. Yet he established his own reputation in the art world through his uniquely subversive videos. During the seventies, McCarthy filmed himself covering his body with paint and liquid food products. In *Painting Face Down—White Line* (1971), the artist dipped his entire face in white paint. He then slid face down across the ground to produce a fat white line. In *Sauce* (1974), McCarthy used his naked body as a canvas, covering his genitals and other body parts in Heinz ketchup. These sexually charged works exposed the carnal nature of the artistic process. They also touched upon on the commercialization of art and sex.

Other McCarthy films examined domestic violence, often using characters from iconic children's stories. In *Pinocchio 2* (1994), the artist dressed up as a Disney version of the famous wooden boy. Yet McCarthy played Pinocchio as a maniacal father figure, one that force-fed liquid through the tube-nose of a defenseless "child" Pinocchio puppet. This graphic depiction of abuse was intensified by the artist's claustrophobic set, a tiny makeshift room punctured with holes. McCarthy probed similar themes in *Heidi* (1992), a film that he produced with fellow conceptual artist Mike Kelley. The work featured a grotesque Heidi puppet engaged in sexual acts with the novel's chief male characters: Grandfather and Peter. Both of these films had a certain shock value that repulsed many viewers. But their graphic details effectively portrayed the terrible intensity of childhood trauma. The films also questioned the value of child-oriented commercial entertainment.

McCarthy's early career was spent in relative obscurity, but he achieved widespread prominence in the nineties after many younger artists cited him as a major influence on their work. McCarthy began to exhibit his art more widely, and he received larger and more varied commissions. One of his exhibits, *White Snow* (2009), was devoted to drawings and collages based on the Disney film *Snow White*. Some of the show's larger works featured Snow White morphing into a riot of phallic symbols and tawdry clippings from celebrity magazines. These pieces examined the relationship between commodity and cultural dysfunction.

The artist also began experimenting with sculptural forms, often designing huge, balloon-like works for outdoor exhibition. *Piggies* (2007) featured two giant piglets, animals that symbolized the fleshy, gluttonous nature of human existence. McCarthy joyfully exposed the piglets' rolling body fat—as well as their raised rear ends and genitals. In another balloon sculpture, *Blockhead* (2003), McCarthy designed a character that mixed pop-culture references with ideas from his own imagination. The character's monumental square head, complete with Pinocchio-style nose, appears to be crushing its body underneath. Bubbles of fat in the neck and chest seem about to burst—ready to release the bodily fluids that have long been integral to McCarthy's art. *bf*

1945 Born in Salt Lake City, Utah
1969 Studies art at the University of Utah and the San Francisco Art Institute
1972 Studies film, video, and art at the University of Southern California, Los Angeles
1982–2002 Teaches performance, video, installation, and performance art history at the University of California, Los Angeles

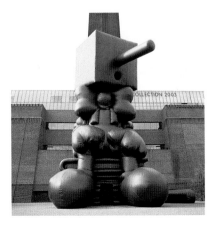

left
Paul McCarthy, *Blockhead*, 2003, steel, vinyl coated nylon, fans, rigging, wood, vending machines, hard candy bars, paint, glass and rope, installation at Tate Modern, London, Courtesy the artist and Hauser & Wirth

above
Paul McCarthy, 2001, Courtesy the artist and Hauser & Wirth

1945 Beginning of the Cold War

1953 Hillary and Tenzing make first successful ascent of Mount Everest

1970 Robert Smithson creates *Spiral Jetty* in Great Salt Lake, Utah

1961 Founding of Amnesty International

1920 1925 1930 1935 1940 1945 1950 1955 1960 1965 1970

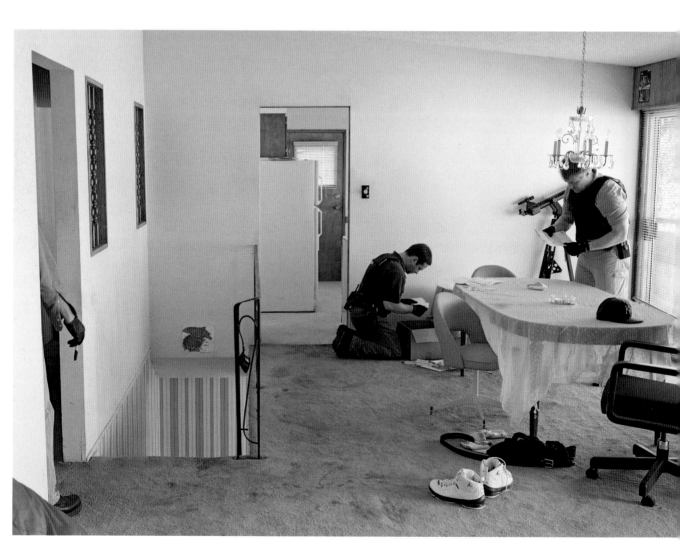

Jeff Wall, *Search of Premises*, 2009,
color photograph, 192 x 263 cm,
Courtesy of the artist

2007–9 Global financial crisis

1977 First *Star Wars* film by
George Lucas

1989 Portable Game Boy console launched

2001 9/11 Islamic terrorist
attacks

2010 21st Olympic Winter Games
in Vancouver

1996 First cloned mammal
(Dolly the Sheep)

1975　1980　1985　1990　1995　2000　2005　2010　2015　2020　2025

JEFF WALL

The work of Jeff Wall is of seminal importance for contemporary photography, particularly in his use of lightboxes and appropriation of advertising aesthetics. The Canadian artist combines in his images elements of photography with aspects of painting and film.

Jeff Wall studied art history and visual art at the University of British Columbia in Vancouver from 1964 to 1970, after which he did three years of postgraduate work at London's Courtauld Institute of Art. In the late seventies, a time when photography was generally being exhibited in small-format black-and-white prints, Wall exhibited large color slides in lightboxes.

Symbols of modern life
He initially chose his subjects arbitrarily, as Wall explains, generally "invisible things that fascinate as soon as you pay attention to them." Taken with a large-format camera, the pictures are carefully composed and pin-sharp, but on a closer look their brilliant beauty often turns out to be illusory. Wall focuses principally on urban and suburban scenes in and around Vancouver, with their social inequalities and conflicts, showing poverty, unemployment, prostitution, black marketing and drug dealing, and unspectacular backwaters as symbols of human exploitation and destructiveness.

The photographer's targeted intervention
Wall has also developed a cinema-based rather than photographic production method. He devises and sets up scenes in the studio or on location as would a film director, photographs them, and does extensive digital processing on them before considering them finished works. Photojournalists rarely have success with such tight, perfect images. The photos come across as freeze-frames, snapshots from an ongoing story. *Mimic* (1982), one of Wall's "quasi-documentary" images, shows a man making a racist hand gesture Wall had previously seen on the street, and subsequently replicated with professional actors. "The spontaneous is the most beautiful thing that can appear in a picture, but nothing in art appears less spontaneously than that," Wall has said.

Along with the intensive exploration of photographic and cinematic strategies, it is Wall's

knowledge of art history and his study of painting that has most influenced his work. Many of his photo tableaux, since the nineties often in black and white, take their subject matter and composition from nineteenth-century realism, with direct allusions to works by, for example, Delacroix, Velázquez, or Manet. Wall has also made a name for himself as an author of groundbreaking art-historical studies of postmodernist art. He lives and works in Vancouver. cw

1946 Born in Vancouver, Canada
1964–70 Studies art history at the University of British Columbia, Vancouver
1970–73 Doctoral research at the Courtauld Institute, University of London
SINCE 1987 Teaches at the Centre for the Arts, University of British Columbia, Vancouver
1982 Takes part in Documenta 7, followed by participations in Documenta 8, 10, and 11
2003 Awarded the Roswitha Haftmann Prize for the visual arts, Zurich
2006 Jeff Wall is made a member of the Royal Society of Canada
2008 Awarded the Audain Prize for Lifetime Achievement, British Columbia

left
Jeff Wall, *War Game*, 2007, silver gelatin print, 247 x 302.5 cm, Courtesy of the artist

above
Jeff Wall, undated

following double page
Jeff Wall, *In Front of a Nightclub*, 2006, transparency in lightbox, 226 x 361 cm, Courtesy of the artist

1949 Premiere of Arthur Miller's
play *Death of a Salesman*

1965 First Op Art exhibition,
The Responsive Eye, in
New York

1959 Alaska and Hawaii become
the 49th and 50th states

1920 1925 1930 1935 1940 1945 1950 1955 1960 1965 1970

Richard Prince, *The Blue Cowboys*,
1999, 4 Ektacolor photographs,
150.5 x 211.5 x 5.1 cm, Courtesy
Gagosian Gallery, New York

RICHARD PRINCE

The art of Richard Prince dissects American culture by re-creating images from advertising and the mass media, as well as from marginalized parts of society. Often his works focus on the complex nature of sex and sexual desire.

Richard Prince is both a scavenger and an artist. Settling in New York City after college, he showed a fascination for photographs that explored American popular culture. Prince avidly collected these images and included them in his art. At first, he developed collages from the photographs he found. But in the late seventies, he began producing his own photos that meticulously recreated, or "rephotographed," pieces from his collection. Prince felt that by displaying these rephotographs as art, he could help a new generation of viewers reinterpret the culture of their recent past—and see their own era in new ways.

So the artist hired models and carefully reconstructed settings. Some of his most famous rephotographs depicted the Marlboro Man, a symbol of fifties American masculinity. Yet Prince's version of this icon reflected dramatic cultural changes that had occurred since the sixties. The Marlboro Man had become a more complicated figure. He now represented the greed of the cigarette industry that had created him—an industry that seemed indifferent to the health problems associated with their product. Prince's Marlboro Man also embodied a new, sexually charged version of the American cowboy, one that had special appeal for the gay community.

Prince explored sex and sexual desire in other ways within his art. His "nurse paintings" featured masked nurse figures that seemed pulled out of seventies horror movie posters. Prince set the figures against ominously colored backgrounds, and he incorporated such melodramatic "titles" as *Sonic Nurse* and *Runaway Nurse*. These works poked fun at the campy eroticism of low-budget horror films. They also commented on the way women become marginalized and objectified by the American mass media.

In another group of paintings, Prince largely eliminated representational imagery. Instead he presented the texts of jokes as the pictures' central

"figures." The jokes covered a variety of subjects, including sex and religion, and they were often unfunny. Prince's main interest in this format was to see how effectively he could make compositions out of lines of text. His basic solution was to run the texts horizontally across the middle of the painting. Individual letters sometimes blended into the picture's painted surface, and words would get cut off at the edges of the canvas. Prince has said that his inspiration for these works came from magazine cartoons. "I decided to drop the image," he stated, "and just concentrate on the punch line. I was misrepresenting the cartoons by calling them jokes." The artist had discovered a way of blurring the functions of text, language, and image.

Prince also had a strong interest in marginalized segments of U.S. society. His "gangs" series portrayed bikers and other characters on the American fringe. The term "gang" not only referred to the people in the photographs, but also to the way Prince grouped the pictures together in album-like sheets. This technique enabled the artist to juxtapose his "gang members" in provocative ways.

Prince's best-known foray into sculpture also captured the transient nature of life on the road. He produced a series of painted car hoods from vintage automobiles. In one of these works, *My Way* (2004), the hood is placed upright like a canvas—with the painted decoration evoking an abstract highway. *bf*

1949 Born in the Panama Canal Zone
1976 First solo exhibition at the Ellen Sragow Gallery, New York
1980–87 Works on the series *Cowboys* taken from Marlboro cigarette advertisements
1988 Takes part in the 43rd Venice Biennale
1992 Takes part in Documenta 9
2007–8 *Spiritual America* retrospective at the Solomon R. Guggenheim Museum
2007 Collaboration with Marc Jacobs for the 2008 Louis Vuitton spring collection

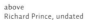

right
Richard Prince, *Untitled (Nurse)*, 2006, acrylic and inkjet on canvas, 152.4 x 121.9 cm, Courtesy Gagosian Gallery, New York

above
Richard Prince, undated

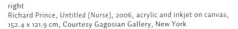

1954 Premiere of Hitchcock's
film *Rear Window*

1967 Race riots in
many US cities

1963 Assassination of
John F. Kennedy

1920　1925　1930　1935　1940　1945　1950　1955　1960　1965　1970

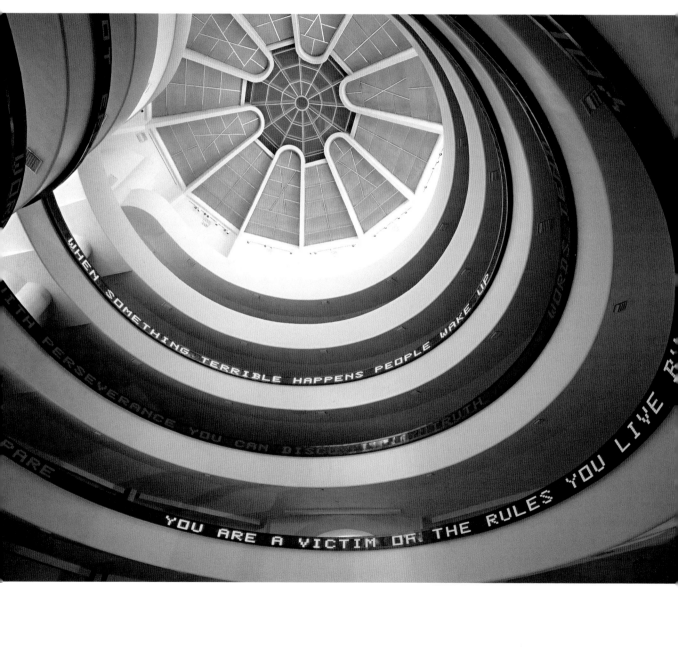

Jenny Holzer, *Untitled (Selections from Truisms, Inflammatory Essays, The Living Series, The Survival Series, Under a Rock, Laments and Child Text)*, 1989, installation, 41.9 x 4900 x 15.2 cm, Solomon R. Guggenheim Museum, New York

1981 Ronald Reagan sworn in
as 40th US president

1976 Helmut Newton publishes
his book *White Women*

1994 Tutsi genocide in Rwanda

2002 US opens detention camp
in Guantánamo

2010 Earthquake in Haiti kills 220,000

1975 1980 1985 1990 1995 2000 2005 2010 2015 2020 2025

JENNY HOLZER

Jenny Holzer works with language as a fundamental artistic material to achieve a social impact. Her forceful textual messages, generally in public space, aim to catch the attention of passers-by in a productive manner, and where they least expect it. She sees herself "as a public orator voicing private fears."

New York, the late seventies: provocative messages begin to appear on billboards, subway cars, street signs, and at construction sites; they read: "religion causes as many problems as it solves" or "the family is living on borrowed time." These are among the everyday bromides in Jenny Holzer's collection of *Truisms* she herself distributed throughout the city. Put together to form a cohesive body of work, the dubious nature of the systems of thought behind such apparently simple maxims becomes quite clear. Seemingly "true" by themselves, things she says such as "children are the most cruel of all" and "children are the hope of a future" are mutually exclusive or indeed contradictory. In 1982, selected Holzer truisms appeared on an LED billboard in New York's Times Square, where she exploited a spectacular medium for her aims. In the midst of news boards and advertisements whose methods she availed herself of, she sought to grab the attention of passers-by for just one moment in their everyday life and prompt them to ponder. By using a modern font in capitals, she unobtrusively but all the more disconcertingly smuggled her messages into public space.

In 1996, Holzer began using xenon projections to display her texts—on the Jewish Museum in Berlin, the pyramid at the Louvre in Paris, Rockefeller Center in New York, in public squares and on rivers. Her works can also be found in conventional museum contexts. For the retrospective at New York's Guggenheim in 1989–90, she displayed a special sensitivity for architectural context and ran more than three hundred of her messages on an LED ticker tape around Frank Lloyd Wright's famous spiral rotunda. The advertising style script formed an interesting contrast with the almost religious-looking granite benches on which Holzer had etched some of the messages.

Shocking aesthetic

Violence, war, fear, death—Holzer's works confront us with existential themes and controversial realities in society. Over time the artist developed an idiom that also expressed personal issues. "Da wo Frauen sterben bin ich hellwach" (Where women die, I am wide awake) was written in capital letters on the cover of the *Süddeutsche Zeitung* magazine on November 19, 1993. Printed with a mixture of blood and printer's ink, it was a provocative attempt to draw the attention to the rape and sexual murders in Bosnia of those readers who, calmly reading the newspaper every day, act as mere spectators. "When we finally touch the blood, when we really have it on our hands, then we are shocked," is Holzer's view. Called *Lustmord* (Sex Murder), this work included a series of photos for which she photographed words written on human skin from the respective perspectives of perpetrators, victims, and those left behind. "When I write I crawl into myself—or into the soul of someone else—and investigate: what's going on? What's happening? This curiosity drives me and the further I go the more dismal it gets." *cw*

1950 Born in Gallipolis, Ohio
1975 Enrolls as a student of painting at the Rhode Island School of Design in Providence
1977 Moves to New York City
1982 Her work is shown in the form of aphorisms on a constantly changing advertising LED billboard in Times Square, New York
1989–90 Holds solo show at the Guggenheim Museum, New York
1990 Awarded the Golden Lion at the 44th Venice Biennale
2002 Awarded the Chevalier de L'Ordre des Arts et des Lettres by the French Republic

Jenny Holzer, undated

1954 J. R. R. Tolkien publishes
Lord of the Rings

1966–76 Chinese
Cultural
Revolution

1959 China annexes Tibet

| 1920 | 1925 | 1930 | 1935 | 1940 | 1945 | 1950 | 1955 | 1960 | 1965 | 1970 |

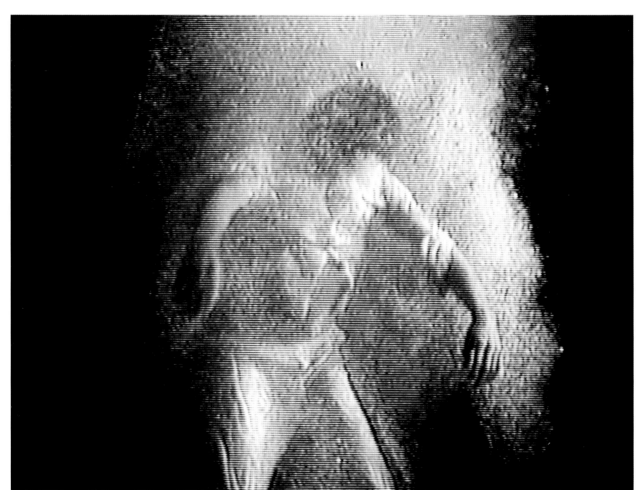

Bill Viola, *The Passing* (*In memory of
Wynne Lee Viola*), 1991, videotape, black
and white, mono sound, 54 min.

1973 First commercial personal
computer

1980 First Alternative Nobel Prize
awarded in Stockholm

1995 First Tamagotchi electronic
pet launched

2004 Disastrous floods in Asia

2009 Actor David Carradine dies in Bangkok

2006 Saddam Hussein executed in Baghdad

1975 1980 1985 1990 1995 2000 2005 2010 2015 2020 2025

BILL VIOLA

Where do we come from, what are we, where are we going? It is these questions American artist Bill Viola tackles in his work. He is one of the most internationally acclaimed video artists, always advancing into new technical and aesthetic terrain, and has made an incalculable contribution toward establishing video as a contemporary artistic medium.

Viola has been closely associated with the medium of video since the early seventies. He has experimented with various techniques such as slow motion, time lapse, zoom, multiple exposures, etc., with which he comprehensively explores states of consciousness and self-perception. He employs the insights of Zen Buddhism, Islamic mysticism, and European philosophy as much as the latest findings in neuroscience and the cognitive sciences, and draws new impulses for his work from his travels to places such as Bali or Tunisia, and longer stays in Italy and Japan.

Viola uses basic life experiences such as birth and death as his subject matter. His rather personal video *The Passing* (1991) goes back to an autobiographical event—exactly nine months after the death of Viola's mother, his second son Andrei was born. Bill Viola shot *The Passing* mainly with night-vision cameras to create a world in which dream and reality converge. The director is himself the principal character, floating between sleep and wakefulness, with images passing before his mind's eye during a brief struggle with death.

Mundus in gutta

In Viola's work, ephemeral events become metaphorical images of universal import. In the closed-circuit process used mainly by him, the recording medium—the camera—is linked with the communication medium—for example, the monitor—in a closed circuit. In the video/sound installation *He Weeps for You* (1976), individual drops of water well up slowly and steadily from a water pipe hanging from the ceiling. A camera projects the slow dripping of the water, which on landing on an amplifying tambourine creates a loud thud, visually magnified on a screen. "Small drops of water—each containing the whole world," comments Viola. Visitors to the exhibition are part of the work—if they step in front of the projector, their image is reflected on the screen and they can watch it steadily getting

bigger within the drop of water. They thus are invited to actively participate in exploring the work's meaning.

Bill Viola studied at the experimental studios of the College of Visual and Performing Arts of Syracuse University, New York, and when just starting out assisted established video artists such as Nam June Paik and Bruce Nauman. An important element in his work is the acoustics, produced since the late seventies by his wife Kira Perov. He also worked with composer David Tudor, one of the pioneers of twentieth-century electronic and experimental music.

Viola has participated in the Documenta and Venice Biennale several times, representing the United States at the latter in 1995 with *Buried Secrets*. He lives and works in Long Beach, California. *cw*

1951 Born in New York City
1973 Graduates from Syracuse
University, New York
1980 Marries curator Kira Perov
1995 Represents the United States at
the 46th Venice Biennale
2003 Awarded the Cultural Leadership
Award, American Federation of
Arts
2005 World premiere of his production
of Richard Wagner's opera *Tristan
and Isolde* in Paris

Bill Viola, undated

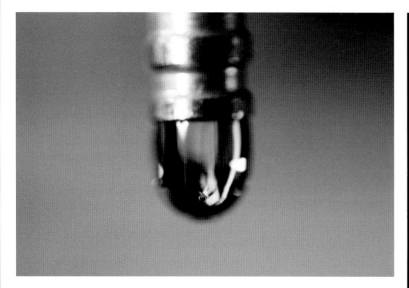

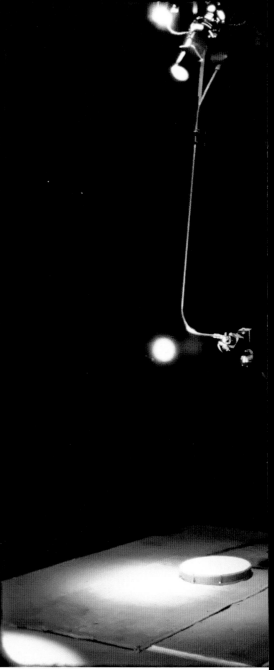

Bill Viola, *He Weeps for You*, detail,
1976, video/sound installation,
370 x 790 x 1100 cm, water drop from
copper pipe, live color camera with
macro lens, amplified drum, video
projection in dark room

1954–62 Algerian War **1963** Martin Luther King
"I have a dream" speech

1920 1925 1930 1935 1940 1945 1950 1955 1960 1965 1970

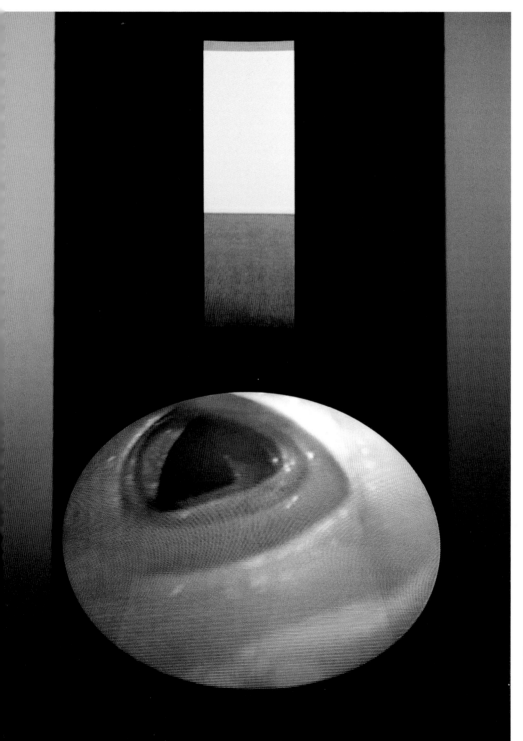

Mona Hatoum, *Corps étranger*,
1994, video installation with
cylindrical wooden structure,
video projector, video player,
amplifier and four speakers,
350 x 300 x 300 cm, Courtesy
Centre Pompidou, Paris

1982 Michael Jackson releases *Thriller*

1975 Pol Pot comes to power
in Cambodia

1994 Nelson Mandela is first black
president of South Africa

2001 The war in
Afghanistan begins

2006 Montenegro declares independence
from Serbia

2009 US Airways flight ditches in the
Hudson River in New York

| 1975 | 1980 | 1985 | 1990 | 1995 | 2000 | 2005 | 2010 | 2015 | 2020 | 2025 |

MONA HATOUM

As a Palestinian who grew up in Lebanon, Mona Hatoum is extremely vigilant when it comes to political injustice. Her work grows out of her struggle against institutional violence, the threat to and vulnerability of the individual. She seems to go along with the public's expectations, only to subsequently overturn them.

Mona Hatoum was in England when civil war broke out in her homeland in 1975, preventing her from returning to her family in Beirut. Since then she has lived in London and, since 2004, Berlin. Describing herself as a "professional residency artist," she attributes part of her creativity to being a foreigner, and has frequently worked in international studio programs. A 1988 video vividly illustrates how she employs her position as an exiled artist and her search for a homeland as subjects. *Measures of Distance* features footage of her naked mother in the bathroom as extracts of handwritten letters in Arabic sent to the artist from Beirut are super-imposed on the screen. The artist's voice reads an English translation of the letters.

Responding to political events in the early eighties, Hatoum confronted her public with graphic performances. In *Under Siege* (1982), she struggled naked with mud in a shower-like cell for hours as she attempted to get a foothold. The action was aurally accompanied by Lebanese folk songs alongside news reports and discussions about the Palestine conflict. Hatoum's unsuccessful attempts to get up and her repeated slipping on the walls of her prison all brought out the futility and senseless-ness of human action against a backdrop of impend-ing war. A week after its performance in London, Israel invaded Lebanon.

Seductive beauty
Hatoum's Object Art and her installations, which bear a certain relation to Minimalist sculpture and Conceptual Art, are enriched by both political and personal content. Steel, glass, and barbed wire conscientiously employed—through changes in pro-portion or function—serve to transform everyday items into alien objects. A latent violence becomes apparent only on a closer look—when, for example, the handles of an invalid's wheelchair are sharp blades, crutches are made of soft rubber, or colorful glass balls on a dissecting table turn out to be hand

grenades. *Daybed* (2008), a kitchen grater blown up to the size of a bed, promises discomfort rather than rest and relaxation. And yet it is pleasing to look at. Such aesthetically attractive objects evoke contra-dictory feelings; with their surprising perils they capture the instability of the world in compelling images.

"I like the work to operate on both sensual and intellectual levels," declares Hatoum. "Meanings, connotations and associations come after the initial physical experience as your imagination, intellect, psyche are fired off by what you've seen." In the 1995 installation of the *Corps étranger*, nominated for the Turner Prize, the body is treated as inanimate matter and a victim of the violence practiced on it. An endoscopic camera examines the surface of the artist's body and then suddenly penetrates inside it. Accompanied aurally by the sounds of heartbeats and breathing, the work is about the disregard for boundaries, which is perceptible not only physically but also psychically. cw

1952 Born in Beirut, Lebanon, to
Palestinian parents
1975 Studies at the Byam Shaw School
of Art in London
1981 Graduates from the Slade School
of Art, London
1995 Nominated for the Turner Prize
2008 Awarded the Rolf Schock Prize

left
Mona Hatoum, *Under Siege*, 1982,
performance, Courtesy White Cube,
London

above
Mona Hatoum, undated

1955 Rosa Louise Parks sparks the
Montgomery Bus Boycott

1960 17 African colonies gain
independence

| 1920 | 1925 | 1930 | 1935 | 1940 | 1945 | 1950 | 1955 | 1960 | 1965 | 1970 |

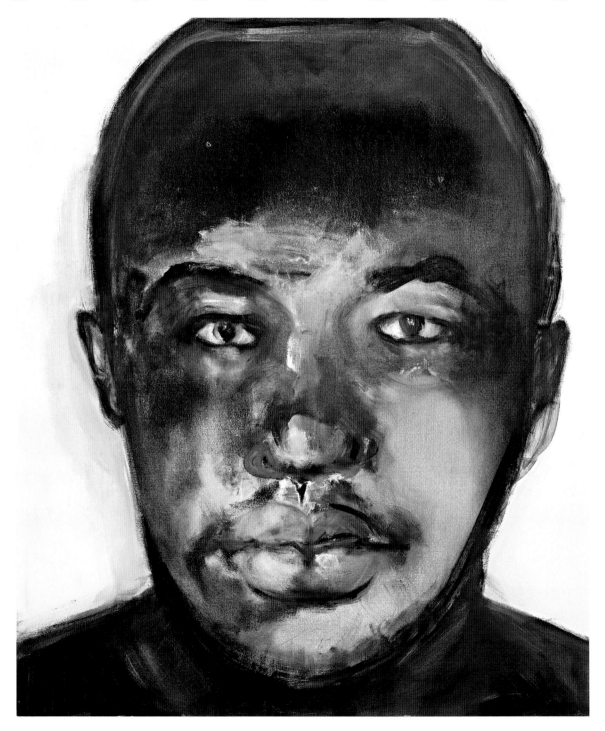

1975 Pol Pot comes to power in Cambodia

1985 Live Aid concert for Africa

2007–9 Global financial crisis

2003 Human genome project completed

1994 End of apartheid in South Africa

2010 French-American sculptor Louise Bourgeois dies in New York

| 1975 | 1980 | 1985 | 1990 | 1995 | 2000 | 2005 | 2010 | 2015 | 2020 | 2025 |

MARLENE DUMAS

Dumas's figures have a pale, ghostly quality. Yet they touch upon very earthly concerns: sex, reproduction, motherhood, and advancing age. Many of her most prominent works explore how the lives of women can be defined and reinterpreted through potent images.

Marlene Dumas was born near Cape Town, South Africa, and she grew up in a culture suffocated by apartheid and international isolation. Like many promising South African artists, she moved to Europe—settling permanently in Amsterdam in 1976. Over the following years, the path of history forever changed her South African homeland, and Dumas' own art began to examine the evolution of human lives.

The paintings of Marlene Dumas are based on photographs that she collects from newspapers, magazines, and other sources. They are details—sharply highlighted faces and bodies—that have been stripped of their original context. Dumas uses a restrained color palette and subtle shading to transform her figures in surprising ways. For example, many of her painted infants appear forbidding and almost frightening. The figure in *Die Baba (The Baby)* (1985) is shown with an angry, defiant countenance. By contrast, Dumas' portraits of older children often reveal more vulnerability. In *Helena's Dream* (2008), Dumas presents her own daughter's face as somewhat self-conscious—even in sleep. Critics have interpreted such works as reflecting the fears that women experience during both pregnancy and motherhood.

Dumas has also specialized in portraying subjects at the end of life. In her series of painted corpses, she focuses on the dead bodies' heads. These "severed" faces take up nearly the entire canvas, with their ghostly skin and expressionless countenance clearly exposed. Dumas' corpses raise questions about how society deals with mortality and change.

Many of Dumas' best-known works reinterpret the art of celebrity portraiture. These paintings often reject the celebrity's popular image and explore cultural attitudes that underlie that image. Her 2008 painting of Ingrid Bergman is based on a tearful still from the film *For Whom the Bell Tolls*. Dumas presents Bergman's wholesome beauty in a distorted way, with skin and lips almost hanging off the face. The work seems to comment on the fleeting nature of beauty—beauty often commodified by the movie industry—and the inevitability of age and death. By contrast, her portrait of Osama Bin-Laden reveals the terrorist leader as a thoughtful, almost docile presence. This work seems to reject the simplistic vilification of even the most controversial public figures.

Dumas also comments on the ways that popular images can define women. Her painted re-creations of erotic photographs, including *Adult Entertainment* (2000), *Feather Stola* (2000), and *High-Heeled Shoes* (2000), probe themes of voyeurism and social entrapment. Another series of works explores the possibilities of the self-portrait, both in paint and in photography. The artist does not idealize her features, and she shows the marks of her age. Some of Dumas' self-portraits even have the same pale countenance as her painted corpses. Such works seem to reject the struggle for eternal youth that contemporary society often demands of women. They also continue a long tradition in the art of Amsterdam; a tradition going back to Rembrandt van Rijn and other Dutch Masters. *bf*

1953 Born in Cape Town, South Africa
1972–75 Studies painting at the Michaelis School of Fine Arts, Cape Town
1976 Moves to the Netherlands, where she continues her studies at the Ateliers '63 in Haarlem
1979–80 Studies psychology at the University of Amsterdam
1995 Represents the Netherlands at the 46th Venice Biennale
2008 The Museum of Contemporary Art, Los Angeles shows *Measuring Your Own Grave*, her first American retrospective

left page
Marlene Dumas, *Moshekwa*, 2006, oil on canvas, 130 x 110 cm, Courtesy Zeno X Gallery, Antwerp

above
Marlene Dumas with her work *Self-Portrait at Noon*, 2008, oil on canvas, 90 x 100 cm, Courtesy Zeno X Gallery, Antwerp

Marlene Dumas, *Magnetic Fields*
(*for Margaux Hemingway*), 2008, oil on
canvas, 30 x 40 cm, Courtesy Zeno X
Gallery, Antwerp

Marlene Dumas, *Helena's Dream*, 2008,
oil on canvas, 130 x 110 cm, Courtesy
Zeno X Gallery, Antwerp

NAN GOLDIN

CINDY SHERMAN

TRACEY MOFFATT

1956 Elvis Presley has his first
major hit, "Heartbreak Hotel"

1961 John F. Kennedy sworn in
as the 35th US president

1966–73 Construction of the
World Trade Center in
New York

| 1920 | 1925 | 1930 | 1935 | 1940 | 1945 | 1950 | 1955 | 1960 | 1965 | 1970 |

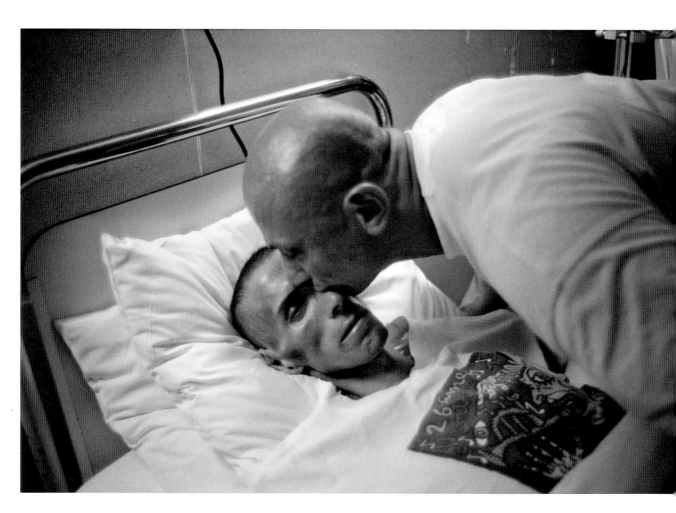

above
Nan Goldin, *Gotscho Kissing Gilles*, Paris,
1993

right page
Nan Goldin, *Nan One Month After Being
Battered*, 1984

1992 *Projects 34: Felix Gonzalez-Torres* exhibition: billboards in 24 locations throughout NYC

2006 Fidel Castro cedes power to his brother Raúl

1973 US Supreme Court legalizes abortion

1983 Discovery of the AIDS virus, HIV

2001 First same-sex "marriage" in Holland

2009 Michael Jackson dies in Los Angeles

1975 1980 1985 1990 1995 2000 2005 2010 2015 2020 2025

NAN GOLDIN

Nan Goldin is one of the most influential contemporary photographers. "I don't choose people to photograph them," replied Goldin when asked why she often makes society's marginalized and its extremes the subject of pictures, "These photos come from relationships, not from observation." Taken together, her photography is a visual diary of her life.

Nan Goldin was fourteen years old when she left home after her older sister committed suicide. She began to take photographs and took a course at the school of the Museum of Fine Arts and Tufts University in Boston. Since the late seventies, she has found her subject matter mainly among her friends and acquaintances in the subculture of transvestites, drag queens, and homosexuals in New York's Lower East Side. She tries to get inside her subjects with her camera, and captures intimate moments of joy and euphoria as well as solitude, violence, illness, and sorrow.

The fragility of life

Goldin's self-portraits often reflect her relationships with other people, presenting them in intimate sexual situations, and emotionally or physically scarred. The self-portrait *Nan One Month After Being Battered* shows Goldin after her boyfriend had brutally beaten her. The photo is part of one of her most important series, *The Ballad of Sexual Dependency* (1986). Goldin habitually selects from hundreds of slides to compose her series, which she then assembles into slideshows with a sound track and music. "Maybe more than other photographers I don't believe in the single portrait. I believe only in the accumulation of portraits as a representation of a person," writes Goldin. "Because I think people are really complex."

The artist structures her work parallel to critical experiences in her life. Thus the pictures she took in the first ten years in New York were almost exclusively of interiors at night, in Goldin's loft, bars, or clubs. A spell in a detox clinic brought an awareness of daylight, and subsequent work featured exterior shots and landscapes. Photographs from the nineties, such as the *Gilles and Gotscho* series about her dealer in Paris and his partner, document the loss of friends to HIV/AIDS.

Goldin homes in on sympathy, proximity, and intimacy, meaning she often deliberately foregoes

technical refinement. In her snapshot aesthetic, photos sometimes seem unbalanced in color, sometimes blurred. "It's about letting it be what it is. And not trying to make it more or less, or altered. What I'm interested in is capturing life as it's being lived, and the flavor and the smell of it, and maintain that in the pictures…. It really is about this enormous acceptance. About wanting to see the truth and accepting it, rather than trying to make my version of it." Nan Goldin lives and works in New York and Paris. cw

1953 Born in Washington, DC
1968 Begins photographing at age 15
1973 First show of black-and-white photographs of drag queens, in Cambridge, MA
1977 Bachelor of Fine Arts from the School of the Museum of Fine Arts, Boston
1978 Moves to New York City
1990 National Endowment for the Arts Grant
1995 *I'll Be your Mirror*, a film for the BBC
2004 *Sisters, Saints, and Sibyls*, an installation for La Chapelle de la Salpêtrière, Paris

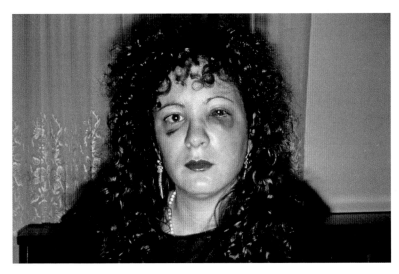

1966 The Curia abolishes
the Index of
Prohibited Books
instituted in 1559

1958 Yves Klein exhibition
Le Vide in Paris

1920 1925 1930 1935 1940 1945 1950 1955 1960 1965 1970

‹ In the Rodin Museum, there is a naked woman with very erotic breasts
and a terrific ass. She is sweet, she is beautiful. ›

Sophie Calle, *The Blind*, 1986

1979 Margaret Thatcher becomes
prime minister of Britain

1992 Maastricht Treaty establishes the EU

1999 First e-book reader

2006 The Musée du Quai Branly opens in
Paris as a French national museum
for non-European art

2010 Degas's painting *Les Choristes* stolen
from a museum in Marseilles

| 1975 | 1980 | 1985 | 1990 | 1995 | 2000 | 2005 | 2010 | 2015 | 2020 | 2025 |

SOPHIE CALLE

Sophie Calle is not an art photographer in the traditional sense, but rather a leading representative of a subjective, narrative photography. Her combinations of photography and text explore all facets of human life, during which the frontiers of art and life, reality and fiction, private and public constantly and playfully shift.

Sophie Calle's first artistic project—an attempt to slip into a stranger's private life without being noticed—brought her international fame. A repeated accidental encounter with an unknown man prompted her to follow him. Equipped with a wig, glasses, and a special lens, she followed him all the way to Venice in 1980. The result was her book *Suite Vénitienne*, a documentation in text and photos of her detective "investigation." The same occurred in the project *L'Hôtel* (1983). Working as a chambermaid in a hotel gave Calle an excuse to search guests' rooms, open drawers and suitcases, and photograph what she found. Her account mixes fact with personal insight, and reveals desires triggered off by the unknown Other.

The reality of Others

Another "action" by Sophie Calle involved an aggravated breach of personal intimacy. In 1983, she found an address book and contacted the people listed in it in order to form a picture of its owner, Pierre D. As time went on, she published in the French daily *Libération* the results of her interviews with members of his family, friends, work colleagues, and acquaintances, who all willingly provided information. This set off fierce debate about the moral aspects of Calle's work, as did her series *The Blind* (1986). Rather than observing anonymously as before, she now took up direct contact with those involved. The work was the result of her asking people born blind about their ideas of beauty. She placed their answers side-by-side with their photographs, together with images of their notions of beauty—in one case, his mother, in another the sea, and in still another the night sky.

Ping-pong with Paul Auster

Despite the photographic "proof," the realism of Calle's works is often open to question. Particularly deceptive is the mixture of fictional and staged events relating to Paul Auster's novel *Leviathan* (1992). The life and work of Sophie Calle provided a model for the writer's fictional character Maria Turner. Calle's response was to literally take over the literary fiction, turn the invented artworks into reality, and make her own life like the heroine of the novel. The confusion is complete when she has a private detective shadow her, like her doppelgänger Maria, only then to hire another detective to follow the first. cw

1953 Born in Paris, France
1979 Returns to Paris after seven years traveling the world. For over a week she invites friends, acquaintances, and strangers to sleep in her bed and then photographs them: *The Sleepers* project.
1992 Paul Auster's novel *Leviathan* is published; one of his characters (Maria Turner) is based on Sophie Calle
2007 Designs the French Pavilion at the 52nd Venice Biennale

Sophie Calle, 2007

1957 Ghana is first African colony to gain
independence after World War II

1960–71 Construction of the Aswan Dam

| 1920 | 1925 | 1930 | 1935 | 1940 | 1945 | 1950 | 1955 | 1960 | 1965 | 1970 |

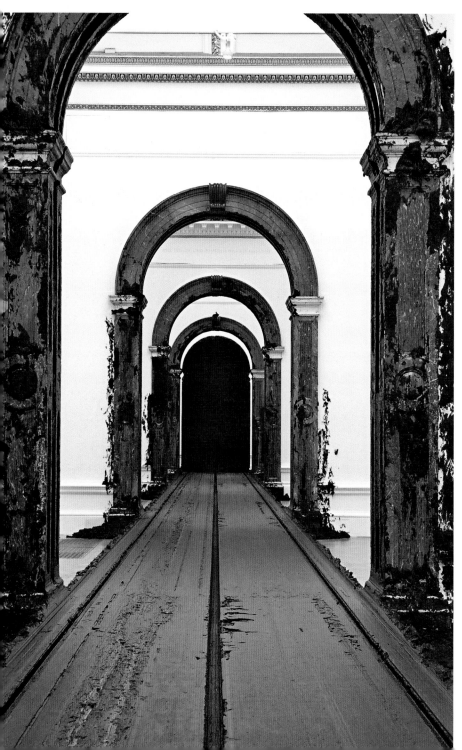

Anish Kapoor, *Svayambh*, 2007, wax
and oil-based paint, installation view,
Royal Academy of Arts, 2009

ANISH KAPOOR

Kapoor's elegant sculptures take pride of place in city squares and museum gallery rooms. Their smooth, often reflective shapes make people see themselves and their surrounding environment in new ways.

The sculpted shapes of Anish Kapoor have a solid yet graceful bearing reminiscent of the curved temples and mosques of his native India. Visitors can explore Kapoor's works from many vantage points, going around and under them and often gazing "inside" their subtle indentations.

In Kapoor's early sculptures, he began to explore the possibilities of shapes and voids. The installation *Turning the World Inside Out II* (1995) featured a single hole in the floor that was filled by a metallic, funnel-like shape. This funnel gave an almost sensuous quality to the hole, revealing the way that space itself could acquire sculptural beauty. In *Resin, Air, Space* (1995), the artist encapsulated a bowl-shaped bubble within a see-through rectangular block. The bubble resembled a solid object, almost like a fossil trapped inside amber. When describing this piece, Kapoor explained, "All I've done is find a way of getting the bubble into the center of the block. A bubble is the moment when space becomes an object, it is a kind of proto-universe."

Gradually the artist experimented with space and form in increasingly larger installations. Some of the works came to fill an entire room, or even connect one room to another. One piece entitled *Svayambh* (2007) was exhibited at several European museums, including Munich's Haus der Kunst. It featured a curved, blood-red sculpture resembling an abstract train car. Made of a wax-like material, this "train" stood on a raised platform that was covered in the same material as the car. When exhibited at the Haus der Kunst, the platform extended past archways in the museum's inner courtyard. The artist even had red wax placed around the archways, making the train appear as though it was in motion. Some critics who saw the piece at the Haus Der Kunst, a 1930s-era museum built under the Nazi government, were reminded of the Nazi death trains that carried prisoners to concentration camps during the Holocaust.

Many of Kapoor's most prominent works were made to be seen in the open air. One example, the stainless steel *Cloud Gate* (2006), stands in Chicago's downtown Millennium Park. Workers spent more than two years constructing the piece, which is covered in hundreds of individual steel plates. These plates were meticulously smoothed down so that the seams between the plates disappeared, leaving an "unbroken" mirror surface. *Cloud Gate* engages viewers by reflecting their own image back at them. Yet its surfaces distort the reflections, so that the viewers get a different impression of themselves and their surroundings as they move around the piece. *Cloud Gate* also stands near some of Chicago's oldest and most iconic buildings, and the reflected images of those buildings remind residents of their place in the city's history. *Cloud Gate*'s unusual shape has even inspired Chicago citizens to give the piece a humorous nickname: the "bean."

The popular success of *Cloud Gate* and other sculptures have made Kapoor an international celebrity. He is now undertaking larger public artworks that require the assistance of architects. One piece under construction was designed for the 2012 Summer Olympics in London. Called the *Arcelor-Mittal Orbit*, it will stand taller than Big Ben, London's great nineteenth-century landmark. The spiraling red body of the tower will incorporate the five rings of the Olympic logo, and its steel frame may somewhat resemble a twisted Eiffel Tower. bf

1954 Born in Bombay, India
1972 Moves to London, where he studies at the Hornsey College of Art
1977–78 Studies at the Chelsea School of Art and Design, London
1990 Awarded the Duemila Prize at the 44th Venice Biennale
1991 Awarded the Turner Prize
2002 Creates the installation *Marsyas* for the Turbine Hall of the Tate Modern, London
2004 His sculpture *Cloud Gate* is installed at the Millennium Park, Chicago
2008 Creates the sculpture *Memory* for the Deutsche Guggenheim, Berlin

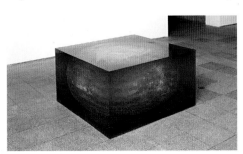

left
Anish Kapoor, *Resin, Air, Space*, 1998, resin, 53 x 105 x 104.5 cm, Private collection, installation view: Hayward Gallery, 1998

above
Anish Kapoor, 2007

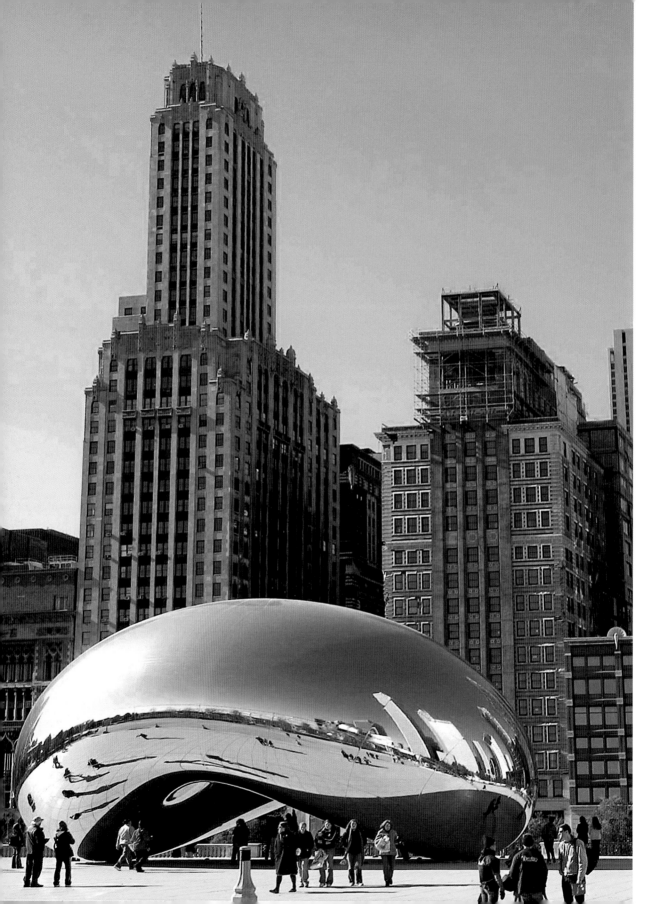

1958 Truman Capote publishes
Breakfast at Tiffany's

1964 Racial segregation
abolished in the US

1920 1925 1930 1935 1940 1945 1950 1955 1960 1965 1970

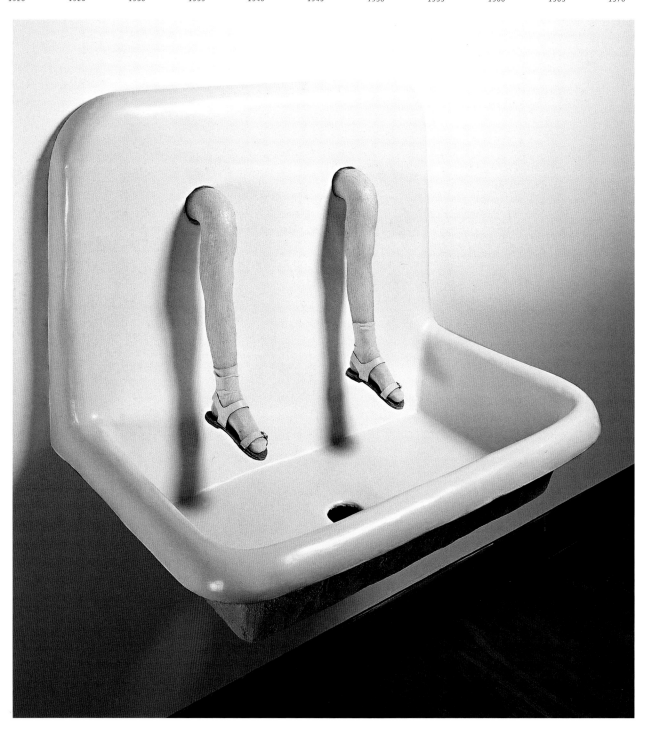

1974 Watergate scandal ends in the resignation of US president Richard Nixon

1986 Explosion destroys US space shuttle *Challenger*

1991 Soviet Union breaks up

2007 iPhone launched

2004 George W. Bush re-elected president

2001 9/11 Islamic terrorist attacks

2010 Earthquake in Haiti kills 220,000

1975 1980 1985 1990 1995 2000 2005 2010 2015 2020 2025

ROBERT GOBER

The finely crafted sculptures of Robert Gober are like bits and pieces of memory. His furniture, suitcases, dismembered legs, and other objects often suggest a bygone era. Yet Gober uses these fragments to explore very contemporary issues.

Robert Gober keeps old traditions alive. He creates his sculptures with a craftsman's precision using wood, wax, and a wide variety of other materials. Even small objects—such as his opened package of butter from 2003 or his wax candle from 1991—are manufactured to the same exacting standards. Though impressive in themselves, these objects take on new meanings when arranged in Gober's provocative museum exhibits, exhibits that often resemble large-scale collages.

Gober's most famous objects are his body-less male legs, which he typically clothes in old-fashioned shoes, socks, and pants. This sense of detail even extends to the limbs' exposed skin, which Gober covers in realistic hair. The artist then exhibits his legs by sticking them onto the sides of bare walls or stuffing them into the darkened corners of rooms. Such placement gives the limbs a surrealist appearance reminiscent of the fractured middle-class bodies painted by Belgian artist René Magritte. The objects also evoke feelings of emotional loss and dislocation from community.

Other Gober installations include furniture that seems to invite the participation of viewers. These works include open playpens that need to be closed, unused beds that need to be occupied, and unhinged doors that need fixing. Gober himself stated that "For the most part, the objects that I choose are almost all emblems of transition; they're objects that you complete with your body, and they're objects that, in one way or another, transform you. Like the ... beds, from conscious to unconscious; rational thought to dreaming; the doors transform you in the sense ... of moving from one space through another." Gober's search for emblems of transition achieved a humorous note in his *Cat Litter* sculptures, which reproduce a bag of cat litter to the smallest detail. Even the advertising logo and user instructions are included. Gober saw the work as a symbol of commitment to an intimate relationship, a commitment "that involved taking care of that

other person's body in sickness and in health." For Gober, his cat litter was the symbolic equivalent of a wedding dress or box of diapers.

Gober's exhibits can also address psychological issues in more direct and forceful ways. Such works incorporate emotionally charged details, but they also retain the artist's natural restraint—characteristics that invite multiple interpretations from viewers. An untitled piece developed in 1997 features a gleaming white, Renaissance-style statue of the *Virgin Mary*. Gober places his figure in a church-like space defined by two open suitcases on either side of the Virgin and a small passageway in back. The peaceful nature of this scene is broken, however, by a large metal pipe stuck through the center of the Virgin's body. Such incongruous imagery speaks to the complex and increasingly fractious role that religion plays in modern life. Another untitled work, created in 1990, features an object that resembles both a human torso and an ordinary sack. Half of the torso is female and the other half male, suggesting the complex nature of sexual identity. Yet another piece from the nineties depicts a pair of child's legs oozing out of a kitchen sink, a work that hints at themes surrounding family dysfunction. *bf*

1954 Born in Wallingford, Connecticut
1972–76 Studies art and literature at Middlebury College, Vermont and the Tyler School of Art in Rome
1984 First solo exhibition in New York
1992 Takes part in Documenta 9
2001 Represents the United States at the 49th Venice Biennale
2007 *Robert Gober: Work 1976–2007*, retrospective at Schaulager, Basel
2010 Curates the exhibition *Diane Arbus: Christ in a lobby and Other Unknown or Almost Known Works* at the Fraenkel Gallery, San Francisco

left page
Robert Gober, *Untitled*, 1999, plaster, beeswax, human hair, cotton, leather, aluminum pull tabs and enamel paint, 85 × 101 × 63 cm, Philadelphia Museum of Art, gift (by exchange) of Mrs. Arthur Barnwell, 1999

above
Robert Gober, undated

1954 Premiere of Hitchcock's
film *Rear Window*

1966–73 Construction of
the World Trade
Center in New York

1961 John F. Kennedy sworn in
as the 35th US president

| 1920 | 1925 | 1930 | 1935 | 1940 | 1945 | 1950 | 1955 | 1960 | 1965 | 1970 |

Mike Kelley, *Day is Done*, 2005, installa-
tion view: Gagosian Gallery, New York

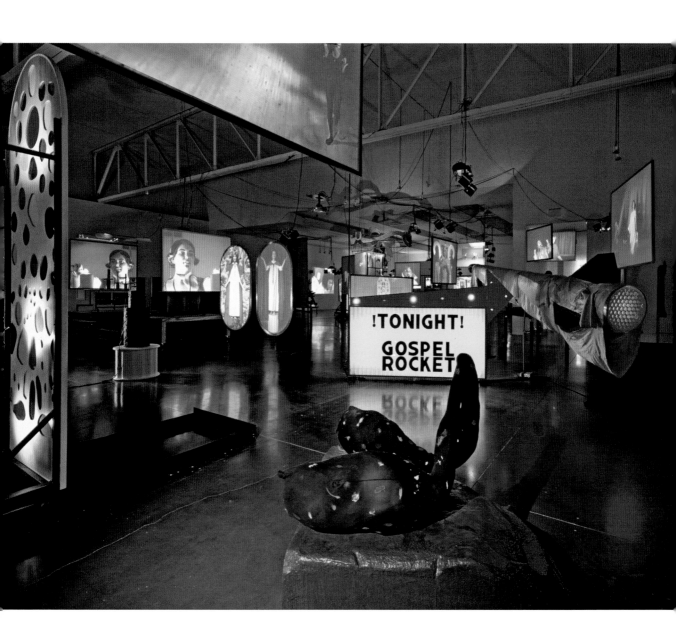

1978 Galápagos Islands is the first place
on the UNESCO World Heritage list

1989 George H. W. Bush sworn
in as 41st US president

1998 Construction of the International
Space Station (ISS) begins

2004 Facebook set up

2007–9 Global financial crisis

2010 Death of actor Dennis Hopper

1975 1980 1985 1990 1995 2000 2005 2010 2015 2020 2025

MIKE KELLEY

Mike Kelley's art is boldly eclectic, combining images from school dances, superhero comics, and small-town newspapers. Some of Kelley's most famous works incorporate the belongings of children: colorful rag dolls, stuffed toys, and other craft objects. These creations seem to suggest motifs of displacement and childhood trauma.

As an adult, Mike Kelley began noticing the monstrous quality of childhood toys. "I had never really looked at dolls or stuffed animals closely before," Kelley has said. "I became interested in their style—the proportions of them, their features. That's when I realized that they were monstrosities … when I blew them up to human scale in paintings they were not so cute anymore; if you saw something like that walking down the street, you'd go in the other direction." Kelley became a collector of these craft objects, and he devised ways of enhancing their "uncute" nature. He sewed some of them together in large quilts, as in *More Love Hours than Can Ever be Repaid* and *The Wages of Sin* (1987). Others he made into odd monster-like formations, even naming one of the pieces *Frankenstein* (1989). Many critics associate these works with the terrors of childhood and domestic abuse, but Kelley does not always agree with such analysis.

Indeed, Kelley's art cannot be confined to a particular theme or medium. He has experimented with film, performance art, and light-filled multimedia installations. In *Test Room Containing Multiple Stimuli to Elicit Curiosity and Manipulatory Responses* (1999/2010), Kelley invited viewers to become part of the creation. His "test room" was an enclosed space containing several objects that resembled abstract playground equipment. Viewers of *Test Room* were encouraged to interact with the sculptures— evoking memories of both the schoolyard and the scientific laboratory. Originally created in 1999, this installation was revived eleven years later when a professional dance troupe performed choreography specifically designed for the test room.

In one of Kelley's smaller works, titled *Repressed Spatial Relationships Rendered as Fluid, No. 4: Stevenson Junior High and Satellites* (2002), he created a miniature school in the form of a mobile. Representations of drawers, desks and other objects from school days were suspended from a thin wire. The mobile's severe, angular appearance was reminiscent of the modernist school buildings from the fifties. Moreover, the piece's moving parts suggested the evolving, fragmented nature of memory. Kelley would further expand on these themes in his exhibit *Day is Done* (2005), which used video, sculpture, found objects, and other media that evoked memories from high school yearbooks. The exhibit's busy, densely packed rooms seemed to represent an adult mind cluttered with the remnants of past experiences.

Kelley also has used offbeat elements from American culture to explore themes of collective memory. His installation series *Kandors* (2007) featured witty recreations of the city of Kandor, a fictional place from the *Superman* comic books. Kandor is the last surviving part of Superman's home planet, Krypton—a city that has become reduced in size and kept in a bottle. Kelley's versions of Kandor were based on illustrations from the original comics. In one version, the bottled city was attached to colorful oxygen tanks, as if on life support. Such imagery revealed the playful side of Kelley's complex art. *bf*

1954 Born in Detroit, Michigan
1976 BFA, University of Michigan, Ann Arbor
1978 MFA, California Institute of the Arts, Valencia, CA
1992 Sonic Youth featured his work on the cover and booklet of their album *Dirty*
2003 John Simon Guggenheim Memorial Foundation Fellowship
2009 Curator of *A Fantastic World Superimposed on Reality: A Select History of Experimental Music*, music festival, New York
2012 Dies in Los Angeles, CA

left
Mike Kelley, *Kandors*, 2007, installation view: Jablonka Galerie, Berlin

above
Mike Kelley, undated

1961 John F. Kennedy sworn in
as the 35th US president

1957 Soviet Union launches
the first *Sputnik*

1966 Barnett Newman paints
Who's Afraid of Red,
Yellow and Blue?

1920　　1925　　1930　　1935　　1940　　1945　　1950　　1955　　1960　　1965　　1970

Cindy Sherman, *Untitled*, 1987, color photograph,
119.4 x 180.3 cm, Courtesy of the artist and Metro
Pictures

1973 Premiere of Richard O'Brien's
The Rocky Horror Show

1987 Black Monday (October 19) sees
markets crash worldwide

1995–99 Power station converted
into the Tate Modern in London

2008 US Pop artist Robert Rauschenberg dies

2010 Picasso's *Nu au plateau de sculpteur*
fetches $106.48m at Christie's

2005 Joseph Ratzinger elected pope (Benedict XVI)

| 1975 | 1980 | 1985 | 1990 | 1995 | 2000 | 2005 | 2010 | 2015 | 2020 | 2025 |

CINDY SHERMAN

American artist Cindy Sherman is among the most important representatives of staged photography. In her case, she acts not only behind the camera but also in front of it. With her constant role-playing—sometimes playful, sometimes caustic, and occasionally brutal—she exposes the illusion of appearances.

Born in Glen Ridge, New Jersey in 1954, Cindy Sherman studied painting in high school before switching to photography. Her best-known early work is *Untitled Film Stills* (1977–80), produced over a period of three years and consisting of sixty-nine black-and-white photographs. Sherman was the photographer, director, and principal performer, recreating scenes from films of the fifties and posing as different types of women. The artist parodies the whole gamut of media-driven roles, from jilted lover to femme fatale to the perfect housewife. Her own identity remains concealed behind costumes and wigs. Over time Sherman executed other series that she would number consecutively; the dividing of her work based on content into series and titles was primarily the work of art critics.

Fairytale? More like a nightmare

In the eighties, Cindy Sherman moved to color photography in significantly larger formats. She became increasingly aggressive in putting across her subject matter: ideal images of femininity and beauty as well as conventional projections of sexuality, power, and violence. In *Fairy Tales* (1985), she used dolls and artificial limbs for the first time. In the *Disasters* series (1986–89), she arranged these into disturbing studies of decay, with garbage, moldy leftovers, and bodily waste. The *Sex Pictures* (1992) feature obscene views of bodies and crude sexual practices involving mannequins, prostheses, and anatomical models. Sherman also role-played in the past, recreating in *History Portraits/Old Masters* (1988–90) well-known paintings by Caravaggio or Botticelli. The new photographic versions of her pictorial sources were revolutionary. Using materials from her seemingly inexhaustible stock of props, Sherman slipped into the role of Biblical heroes and Renaissance courtesans, putting on a brazen masquerade with glass eyes, strap-on plastic breasts, and caked-on makeup. Even in the *Clowns* series of 2003–4, the unease, indeed the horror,

goes on. Once again, the artist breaks with the familiar conventions of genre—the expressions on the jesters' faces are enough to freeze any smile. cw

1954 Born in Glen Ridge, New Jersey
1972 Enrolls at the State University of New York (SUNY) at Buffalo, majoring in painting but later switching to photography
1974 Founds Hallwalls Contemporary Art Center with Robert Longo, Charles Clough, and others
1977 Moves to New York City; begins her *Untitled Film Stills* series
1989–90 Creates her *History Portraits* series
2005 Receives the Guild Hall Academy of the Arts Lifetime Achievement Award for Visual Arts
2006 Retrospective at the Jeu de Paume Museum in Paris with works spanning 30 years from 1975 to 2005

Cindy Sherman, undated

above
Cindy Sherman, *Untitled*, 2004, color
photograph, 136.5 x 139.1 cm, Courtesy
of the artist and Metro Pictures

right page
Cindy Sherman, Cindy Sherman, *Untitled*,
2008, color photograph, 178.4 x 137.2 cm,
Courtesy of the artist and Metro Pictures

1948 Assassination of
Mahatma Gandhi

1960 17 African colonies
gain independence

1969 Jonathan
Beckwith
isolates the
first gene

1920 1925 1930 1935 1940 1945 1950 1955 1960 1965 1970

William Kentridge, still from *Journey to
the Moon*, 2003, Courtesy of William
Kentridge and Goodman Gallery

1979–89 Soviet-Afghan War

1994 Nelson Mandela becomes first
black president of South Africa

2009 Freighter *Hansa Stavanger* seized by
pirates off the coast of Somalia

2006 Ellen Johnson-Sirleaf (Liberia) becomes
first female African head of state

1975 1980 1985 1990 1995 2000 2005 2010 2015 2020 2025

WILLIAM KENTRIDGE

The stark images of William Kentridge explore life in his homeland of South Africa, touching upon the country's long history of discrimination and hard-fought change. These images often achieve their greatest potency when incorporated into the artist's animated films.

William Kentridge depicts a world in flux. Buildings and people disintegrate and re-emerge, animals transform into telephones, and splashes of red and blue color invade a black-and-white landscape. Kentridge uses drawings made of charcoal and other materials as the basis for his animated films. He achieves the illusion of movement by making tiny changes to the drawings—either by erasing or adding detail—and then capturing each change on camera. The resulting animations have an expressive yet sometimes emotionally distant quality.

These contradictions reflect the nature of Kentridge's South Africa, a country still in the midst of social upheaval. The artist began making animations in the late eighties, just before the downfall of South Africa's racist apartheid government, and he has continued his work throughout the country's struggle toward democracy. Some of the best-known titles include *Johannesburg, 2nd Greatest City after Paris* (1990) and *Mine* (1991). They feature the characters Soho Eckstein and Felix Teitelbaum. Eckstein is a symbol of the apartheid-era white elite, a business leader seemingly unconcerned with the struggles of the men who work in his factories and mines. Teitelbaum is Eckstein's alter ego, and he often appears as the lover of Soho's wife. Kentridge uses these dual characters to probe the emotional conflicts that continue to plague many white South Africans.

Yet the artist does not focus exclusively on films. He often creates charcoal drawings as stand-alone pieces. In *Pond at Deer Acres* (2002), for example, Kentridge's marshy landscape has the same sense of impermanence as his animated images. The pond almost seems to be disintegrating into the canvas. Kentridge has also experimented with tapestries, as in *Office Love* (2001). The human figure in this work is depicted with the head of a typewriter, and he is set against a background containing pieces from an old map—a reminder of South Africa's colonial past.

Here again, Kentridge depicts the struggles of a people burdened by their history.

In recent years, William Kentridge has found other ways of using his talent for transforming ideas into visual drama. His staging of Dmitri Shostakovich's 1930 opera, *The Nose*, reflects his long-standing admiration for Russian avant-garde art. *The Nose* was based on a nineteenth-century short story by Nicolai Gogol, a story that parodied the tsarist government and its oppressive bureaucracy. Government repression also marked the performance history of the opera, as the Soviet regime banned the work for many decades. In Kentridge's production of *The Nose*, he explores Russia's painful history by incorporating animated films as part of the stage sets. The films feature human characters assembled out of abstract shapes, reminiscent of Russian Constructivist Art of the twenties. They also incorporate old newspapers and bits of black-and-white newsreels. These dense, complex elements give the sets a claustrophobic quality—complementing Shostakovich's dissonant music and bringing out the story's themes of social oppression. Viewers of *The Nose* were often reminded of Kentridge's earlier artwork, and of the way it addressed a similarly illiberal apartheid-era society. *bf*

1955 Born in Johannesburg, South Africa
1973–76 Studies politics and African studies at the University of the Witwatersrand
1976–78 Studies art at the Johannesburg Art Foundation
1981–82 Studies mime and theater at the École Jacques LeCoq, Paris
2002 Takes part in Documenta 11
2003 Awarded the Goslar Kaiserring
2008 Receives the Oskar Kokoschka Award
2010 6th Annual Kyoto Prize for Lifetime Achievement in Arts and Philosophy; the retrospective *William Kentridge: Five Themes* is shown at the Museum of Modern Art, New York

above
William Kentridge, still from
Journey to the Moon, 2003, Courtesy of
William Kentridge and Goodman Gallery

left
William Kentridge, *Man with Globe*,
2008, bronze, Courtesy of William
Kentridge and Goodman Gallery

William Kentridge, drawing from
Preparing the Flute, 2004/05, charcoal
and pastel on paper, 120 x 160 cm,
Courtesy of William Kentridge and
Goodman Gallery

JEFF KOONS

TRACEY EMIN

RICHARD PRINCE

1959 First Barbie doll shown at
toy fair in New York

1955 *The Family of Man* exhibition at the
Museum of Modern Art in New York

1969 Stonewall
riots on
Christophe
Street in
New York

| 1920 | 1925 | 1930 | 1935 | 1940 | 1945 | 1950 | 1955 | 1960 | 1965 | 1970 |

Jeff Koons, *Rabbit*, 1986, stainless steel,
104.1 x 48.3 cm, Private collection

1981 Ronald Reagan sworn in as
40th US president

1999 Columbine High
School massacre

2009 Actor Patrick Swayze
dies in Los Angeles

1977–80 Cindy Sherman produces
Untitled Film Stills

1989 Portable Game Boy console launched

1975 1980 1985 1990 1995 2000 2005 2010 2015 2020 2025

JEFF KOONS

A Jeff Koons sculpture stands like a giant advertisement. His shiny, balloon-like animals and multicolored topiaries remind viewers of the amusement park, and they evoke the problems and contradictions of modern commercialism.

Much like his predecessor Andy Warhol, Jeff Koons creates art that both satisfies and pokes fun at popular culture. Koons became famous in the America of the eighties, a time characterized by the desire to attain wealth and show off one's material trappings. Koons's shiny sculptures became a well-known part of that era. His large inflated rabbits and flowers had the appearance of carnival toys. Moreover, their polished steel surfaces reflected the viewers' image back at them, emphasizing the narcissism of a culture of excess.

The artist even transformed imagery from traditional European art into his own brand of kitsch. His *Kiepenkerl* (1987) statue, which stands outside the Hirshhorn Museum in Washington, DC, represents a traveling salesman from the pre-industrial era—complete with a sack of wares on his back. The figure's body and eighteenth-century garb are depicted with great precision, alluding to the grand baroque statuary of European town squares. But the work's glaringly bright steel surfaces seem to reflect contemporary notions of advertising and salesmanship.

As Koons's career skyrocketed, his art often became grander in scale. The flower-filled topiary sculpture *Puppy* (1992) stands twelve meters high. Its expressionless body is reminiscent of the elaborate animal topiaries in Walt Disney World and other giant theme parks. The piece now stands in front of the Guggenheim Museum in Bilbao, Spain, another institution well known as an international tourist site. Indeed, the sculpture's presence at the Guggenheim seems to blur the distinctions between the amusement park and the art museum.

Koons again addressed the connections between art and commerce when he painted a BMW M3 GTS racing car in 2010. The car, which competed in a professional race at Le Mans, France, featured bright, multicolored striping on its sides and front. On the back end, Koons created an abstract, sixties-style explosion, evoking the fake superhero

cartoons of Pop artist Roy Liechtenstein. This densely packed decoration not only symbolized the car's explosive power and speed, it echoed the way that advertising decals proliferate in auto racing and other segments of sports culture.

Koons has found another way to emulate sixties-era Pop artists—by focusing on the cult of celebrity. His porcelain sculpture *Michael Jackson and Bubbles* (1988) depicts the famous pop star and his pet chimpanzee. This disturbing work resembles the delicate Meissen china sculptures that appeared in collections of eighteenth-century aristocrats. But Koons's image has a very twentieth-century character. Jackson's face appears hard and frozen, and the deep red lips make his countenance almost frightening. Koons seems to suggest Jackson's real-life struggles as an African-American star, and his attempts though plastic surgery to become more physically "acceptable" to a society dominated by white perceptions of beauty.

Koons has also worked hard to promote his own celebrity image. Carefully staged photographs of the artist have become famous in art magazines. These images now proliferate on the Internet, as do stories of Koons's controversial personal life. Like Warhol before him, Koons has earned far more than his allotted fifteen minutes of fame. *bf*

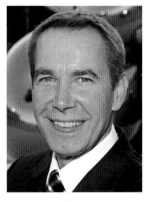

1955 Born in York, Pennsylvania
1972–75 Studies at the Maryland Institute College of Art, Baltimore
1975–76 Studies at the School of the Art Institute of Chicago
1976 Moves to New York City and works as a commodities broker
1980 First solo exhibition at the New Museum of Contemporary Art, New York
1986 Produces *Bunny* and *Luxury and Degradation*
1990 Represented at the 44th Venice Biennale
2000 Turns away from art and publicity for several years
2008 Honorary Doctorate, School of the Art Institute of Chicago
2010 The 17th BMW Art Car created by Jeff Koons raced at the 24 Hours of Le Mans, France

Jeff Koons, undated

1955 First Documenta exhibition
in Kassel

1961 Construction of
Berlin Wall

1970 Willy Brandt's
Warsaw Ghetto
genuflection

1920 1925 1930 1935 1940 1945 1950 1955 1960 1965 1970

Andreas Gursky, *Ocean V*, 2010, C-print,
365.4 x 249.4 x 6.4 cm, Courtesy Sprüth Magers
Berlin London

1977 First *Star Wars* film
by George Lucas

1995 Founding of the World
Trade Organization (WTO)

1998 Founding of the International
Court in The Hague

2009 Cologne city archive collapses

2007–9 World financial crisis

2010 Volcanic ash from Iceland causes
havoc on European airspace

1975 1980 1985 1990 1995 2000 2005 2010 2015 2020 2025

ANDREAS GURSKY

The theme of globalization is always present in Gursky's photographs. His images explore how the worldwide spread of urban technology—skyscrapers, vast road works, and huge city spaces—have changed the way people interact with one another and with different cultures.

Andreas Gursky has made art out of global tourism. His photographs capture the world from a distant, aerial perspective—the perspective of a tourist. Yet they also emphasize the increasingly collective nature of human society. As Gursky has stated, "Space is very important for me but in a more abstract way, I think. Maybe to try to understand not just that we are living in a certain building or in a certain location, but to become aware that we are living on a planet that is going at enormous speed through the universe.... I read a picture not for what's really going on there, I read it more for what is going on in our world generally."

Gursky was born in Leipzig, Germany in 1955, and he began his career studying the techniques of industrial and architectural photographers. By the eighties, he had developed his own pictorial style. Gursky learned to photograph expansive spaces by taking multiple shots on site. He then "combined" photos in the production laboratory to create a single, apparently seamless image. In recent years, Gursky has relied more on digital techniques for producing his photographs. These techniques can add an artificiality to his works that some critics admire and others reject. Yet digital "enhancement" has become just as ubiquitous a part of modern life as the urban jungles of Gursky's photographic world.

Gursky focuses on the ways that modern technology has both connected and alienated people. For example, he explores how contemporary mass culture is enforcing a certain homogeneity around the globe. In *Monaco* (2007), a Formula One auto-racing event transforms the spectacular Monégasque coastline into a generic urban landscape. A similar theme appears in *Salerno* (1995), in which densely packed formations of cars cover the Sicilian port—resembling giant computer chips in the midst of ancient hills. Gursky also depicts the ways that commercialism can engulf human activities. *Chicago Board of Trade II* (1999) shows futures traders cramming together like ants on the trading floor,

while 99 *Cent II Diptychon* (2001) features seemingly unending supermarket shelves filled with bland packaged goods.

Other Gursky photographs indicate how human technology can unwittingly echo the natural world. In *Copan* (2002), apartment buildings from São Paulo, Brazil appear to move in an undulating rhythm; while in *Bahrain I* (2005), a giant racetrack spreads over the desert like a twisted snake. In *San Francisco* (1998), a California hotel lobby evokes the movements of shifting tectonic plates—and of the earthquakes that have long plagued the city.

In his continuing search for new subjects and working methods, Gursky has begun creating artwork from satellite images. His *Ocean* series (2010) depicts the world's seas as vast, amorphous shapes. Each of these images has the look of Abstract Expressionist Art, with the deep-blue ocean color taking up most of the photographic "canvas." Only the edges of continents are able to sneak into the pictures' sides and corners. Though these works depict huge spaces, they also have a delicate quality that highlights the oceans' fragility—bringing environmentalist themes into Gursky's art. *bf*

1955 Born in Leipzig, Germany
1978–81 Studies at the Folkwang School, Essen
1981–87 Studies at the Düsseldorf Art Academy, with Bernd Becher, whose master student he becomes in 1985
1987 Exhibition at the Düsseldorf Airport
1992 Exhibition at Kunsthalle Zurich
2001 Exhibition at the Museum of Modern Art, New York, which travels to Madrid, Paris, Chicago, and San Francisco
2007 Exhibition at the Haus der Kunst, Munich
2008 Awarded the Goslar Kaiserring

Andreas Gursky, undated

1966–76 Chinese Cultural
Revolution

1959 China annexes Tibet

| 1920 | 1925 | 1930 | 1935 | 1940 | 1945 | 1950 | 1955 | 1960 | 1965 | 1970 |

1975 Pol Pot comes to power
in Cambodia

1995 Tamagotchi electronic
pet launched in Japan

1989 Tiananmen Square massacre in Beijing

2004 Catastrophic
floods in Asia

2009 Swine flu epidemic

2010 Researchers at the Westfälische Wilhelms
University discover signs of water on Mars

1975　1980　1985　1990　1995　2000　2005　2010　2015　2020　2025

AI WEIWEI

Chinese artist Ai Weiwei has seen his country transformed by economic revolution, and his art seeks to extend that revolution to Chinese culture and politics. Ai's works also incorporate and reinterpret China's ancient traditions.

Ai Weiwei has always been a political artist. His political activism has its roots in a turbulent childhood. Born in Beijing, Ai grew up in an artistic family. His father, Ai Qing, was one of China's most important poets. Yet shortly after Ai's birth, the communist government under Mao Zedong accused his father of supporting capitalism, and the entire family was exiled to a labor camp in Manchuria. Ai's childhood experiences in the camp helped ignite in him a desire for political change.

During Weiwei's student days, the Chinese economy began incorporating some of the very capitalist ideas for which Ai Qing was denounced. China also began relaxing the cultural restrictions imposed on its people under Mao. Ai was among the first generation of Chinese artists to take advantage of this increased openness. While studying at the Beijing Film Academy in the late seventies, he became part of a group called the "Stars." This group rejected the typical Chinese art of the day, with its bland realism and scenes of obedient socialist workers. Instead, the Stars made art that incorporated Cubism, Surrealism, and other Western styles that had been banned in China. They first exhibited their works in 1979, putting together a makeshift outdoor exhibition in Beijing and openly pushing for greater cultural freedom in their country. One of Ai's artworks from this year, a black-and-white drawing called Forest, depicts a dark forest scene using expressionist techniques.

China soon began relaxing the travel restrictions it had imposed on its citizens under Mao. Ai was able to move to New York City in the early eighties and lived there for more than a decade. While in New York, he continued his studies and refocused his artistic career. Ai began experimenting with conceptual art that tackled social and political issues more directly. When he returned to China in 1993, he brought what he had learned back with him. Ai often explored the awkward blending of capitalism, communism, and traditional culture in China.

In *Neolithic Culture Pot with Coca-Cola Logo* (1997), he commented on the haphazard way that China had been adopting Western values, and the threats that such change might pose to the country's ancient heritage. These themes also appeared in *Forever Bicycles* (2003). Here Ai transformed forty-two Forever brand bicycles, symbols of daily life under Communism, into a Western-style surrealist collage.

Today, Ai has become a true "star" of the art world. His fame has earned him increasingly prominent international commissions. One of Ai's highest profile efforts was his work on the Beijing National Stadium, the centerpiece of China's highly successful 2008 Olympic Games. This daring design, often called the *Bird's Nest*, featured an exposed steel structure and required cutting-edge digital technology to complete. Ai collaborated with the Swiss architectural firm Herzog & de Meuron on the design. When completed, the stadium served as an effective symbol of China's new role in global politics and economics—a symbol that Ai himself came to reject as too artificial and "corporate."

In 2010, Ai unveiled his *Sunflower Seeds* exhibit at the Tate Modern museum in London. Millions of porcelain sunflower seeds were placed on the floor of the museum's Turbine Hall. All of the seeds were hand-painted in a single Chinese town—an homage to traditional Chinese craftsmanship. For the first few weeks after the exhibit opened, visitors were allowed to walk across the seeds, as if exploring a vast, new ocean. *bf*

1957 Born in Beijing, China
1978 Enrolls in the Beijing Film Academy
1981–93 Lives in the United States, where he studies at the Parsons School of Design, New York
1993 Returns to China, where he opens the gallery China Art Archives & Warehouse for experimental art from the People's Republic of China in 1997
2007 Brings 1,001 people from all over China to Kassel for his contribution *Fairytale* to Documenta 12
2010–11 His installation *Sunflower Seeds* is shown at the Tate Modern Turbine Hall, consisting of one hundred million hand-painted porcelain "seeds"

left page
Ai Weiwei, *"Forever" Bicycles*, 2003,
42 bicycles, 275 cm x 450 cm x 450 cm,
Courtesy Mary Boone Gallery, New York

above
Ai Weiwei, undated

1960–71 Construction of
the Aswan Dam

1954–62 Algerian War

1920 1925 1930 1935 1940 1945 1950 1955 1960 1965 1970

1990–91 Persian Gulf War

1983 Civil war breaks out in Sudan

1996 First cloned mammal
(Dolly the Sheep)

2006 Saddam Hussein condemned
to death

1975 1980 1985 1990 1995 2000 2005 2010 2015 2020 2025

SHIRIN NESHAT

"I see my work as a visual discourse on the subject of feminism and contemporary Islam—a discourse that puts certain myths and realities to the test, claiming that they are far more complex than most of us have imagined."
Shirin Neshat, 2000

After graduating from high school in 1974, Iranian-born Shirin Neshat left her homeland to study art in the U.S., ultimately at the University of California, Berkeley. She described her 1990 return to Iran as a shock: the Islamic Revolution had brought about the downfall of Shah Mohammad Reza Pahlavi, the end of the monarchy, and the proclamation of the Islamic Republic. Neshat embarked on an artistic career in the midst of profound change, carrying with her the profoundly contradictory experiences in the West. Living in New York since 1996, her work takes a critical look at her traditional roots and social developments in contemporary Islam, with a particular focus on the strictly regimented position of women.

Politics and poetry

In 1993, Neshat began work on a series of black-and-white photographs of armed Islamic women in full-length chadors. The uncovered parts of the skin—the face, hands, and feet—bear superimposed Persian texts by Iranian women poets. Though the series *Women of Allah* (1993–97) made the photographer well known on the Western art scene, her work has never been exhibited in Iran, where the diverse Persian texts about being captive in Iranian culture or the zeal of the Islamic revolution could actually have been read. For most Western viewers, the script comes across as calligraphic ornament. Neshat's earnest portraits of militant women juxtapose femininity with violence, eroticism, innocence, and aggression. Her video works are also characterized by their dichotomies—between Western and Islamic culture, or generally between men and women, individuals and society, control and desire. They are vivid works devoid of words with a powerfully minimalist black-and-white aesthetic.

Women Without Men

Women Without Men (*Zanān-e bedun-e mardān* in the original Persian) was Neshat's first feature film, which she saw as a natural development and progression from her previous work. Begun in 2003, Neshat spent six years laboring over it, combining art and entertainment to create a personal cinematic language that would reach an audience far broader than the exclusive art world elite she had previously known. In connection with the film, Neshat also simultaneously realized a series of video installations including *Mahdokht* (2004) and *Zarin* (2005). Awarded the Silver Lion for best direction at the Venice Film Festival in 2009, *Women Without Men* is based on Shahrnush Parsipur's eponymous novel, which was banned by the Iranian government when published in 1989. In the film, Neshat tracks the life of four women in Teheran who in different ways had been victims of male violence. Their destinies converge in the summer of 1953, after the overthrow of the democratically elected Iranian prime minister, Mossadegh, by the CIA in collaboration with the Shah's troops. The four find temporary refuge in an enchanted garden outside Teheran, and find that it is possible to live an independent life. Against the backdrop of the presidential elections and revolt of the civil rights movement in Teheran in June 2009, *Women Without Men* proved provocatively topical. The events of 1953 almost seemed to be repeating themselves. As with Parsipur's novel, Neshat's film was blacklisted in Iran. *cw*

1957 Born in Qazvin, Iran
1974 Goes to California to study art, later moving to New York City
1990 Visits Iran for the first time since 1974, and explores the subject of the role of women in Islam
1999 First International Prize at the 48th Venice Biennale
2009 Awarded the Silver Lion at the 66th Venice Film Festival for her motion picture *Women Without Men* (*Zanān bedun-e mardān*)

left page
Shirin Neshat, *Guardians of Revolution (Women of Allah series)*, 1994, black and white RC print and ink, 102.2 x 94 cm, Courtesy Gladstone Gallery, New York

above
Shirin Neshat, 2006

above
Shirin Neshat, *Munis & Revolutionary Man*, 2008, C-print and ink, 124.5 x 230.6 cm, Courtesy Gladstone Gallery, New York

right
Shirin Neshat, *From Mahdokht* from *Women Without Men* series, 2004, C-print, 91.4 x 234.3 cm, framed, Courtesy Gladstone Gallery, New York

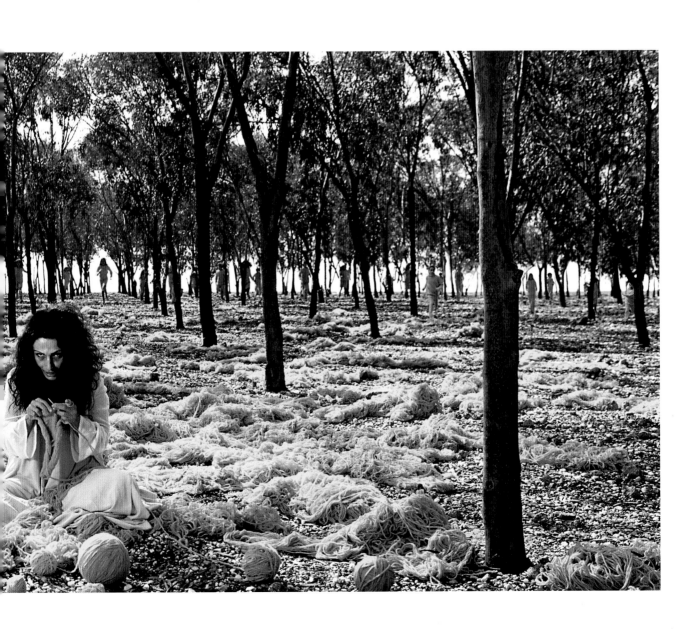

PETER DOIG

NEO RAUCH

DAMIEN HIRST

1960 The Beatles form

1971 Founding of Green peace

1920 1925 1930 1935 1940 1945 1950 1955 1960 1965 1970

Peter Doig, *Black Curtain (Towards Monkey Island)*, 2004, oil on canvas, 200 x 275 cm, Courtesy Contemporary Fine Arts, Berlin

1986 Jeff Koons's *Rabbit*

1996 First cloned mammal
(Dolly the Sheep)

2007–9 Global financial crisis

1992 Maastricht Treaty
establishes the EU

2003 Human genome
project completed

2010 Picasso's *Nu au plateau de sculpteur*
fetches $106.48m at Christie's

1975 1980 1985 1990 1995 2000 2005 2010 2015 2020 2025

PETER DOIG

Doig infuses mystery and complexity into his painted landscapes. These images—with their thick forests, remote lakes, and snowy hillsides—come from the wilderness of Canada. Doig's expressive colors and compositions hearken back to the earlier American landscapes of Winslow Homer and Tom Thomson.

The memories of a Canadian childhood never left Peter Doig. Even though he studied in London and spent much of his adult life working there, Doig developed a style of landscape painting centered on the Canadian outdoors. Yet the artist rarely based his work on direct observations. Instead, he used postcards, photographs, and other collected images as his models. Doig's style took some years to come to maturity. In his early works from the late eighties, he experimented with different approaches. *Milky Way* (1989–90) had a somewhat Fauvist character— its boldly colored, abstract trees seemed to sway on the canvas like human dancers.

Over the coming years, Doig would develop a softer, more impressionistic color palette. He would also begin to structure his compositions in ways that highlighted the loneliness and remoteness of his pictorial scenes. These works evoked the World War I-era Canadian landscapes of Tom Thomson, but with a stronger sense of the ways that wilderness areas can embody human emotions and psychology. Such paintings as *Blotter* (1993), *Coburg 3 + 1 more* (1994), and *Orange Sunshine* (1994) feature isolated people in vast, often intimidating natural worlds. Trees, mist, and snow seemed to envelop these subjects, suggesting the hazy, mysterious nature of memories and dreams.

Such characteristics also appear in Doig's non-Canadian landscapes. Working in Briey-en-Forêt, France, Doig painted images of the Unité d'Habitation building—one of several post-World War II living complexes designed by Swiss architect Le Corbusier. Doig described his inspiration for these works: "The building took me by surprise as a piece of architecture, but it was not until I saw the photographs I had taken of the building through the trees that it became interesting. That made me go back and look at it again. I was surprised by the way the building transformed itself from a piece of architecture into a feeling. It was all emotion suddenly." So Doig used these photographs to paint the structure "through the trees." His finished works presented the modernist icon as a kind of mirage, one that emerged hazily out of a vast maze of tree trunks and branches.

In 2002, Doig moved from London to Trinidad— where his family had lived briefly before they settled in Canada. Soon he began capturing the landscapes of his new home, incorporating the vivid colors of the Caribbean tropics. He also began painting more from memory and experience and less from photographic models. His Trinidad paintings are reminiscent of the late works of Winslow Homer, who captured famous nineteenth-century views of Cuba and the Bahamas. But Doig's Caribbean, like his Canada, is a world saturated by human feelings, desires, and fears. In *Black Curtain (Towards Monkey Island)* (2004), the watery landscape is seen through a curtain-like material. Here the viewer is physically and emotionally separated from a strange world, a world that Doig himself is still in the process of discovering. *bf*

1959 Born in Edinburgh, Scotland
1960–66 Lives in Trinidad
1966–79 Lives in Canada
1979 Moves to London, where he enrolls at the Wimbledon School of Art
1980–83 Studies at the St. Martin's School of Art, London
1989–90 Studies at the Chelsea College of Art and Design, London
1994 Nominated for the Turner Prize
1995-2000 Curator of the Tate Gallery, London
2002 Moves to Port of Spain, Trinidad
2003 Foundation of the StudioFilm-Club in collaboration with Che Lovelace
SINCE 2005 Teaches painting at the Düsseldorf Art Academy
2008 Receives the Wolfgang Hahn Prize, Cologne

Peter Doig, undated

NEO RAUCH

PETER DOIG

SIGMAR POLKE

1961 First man in space (Soviet Union)

1965 Joseph Beuys action
*How to Explain Pictures
to a Dead Hare*

1920 1925 1930 1935 1940 1945 1950 1955 1960 1965 1970

1977 German Autumn
(Baader-Meinhof gang)

1986 Chernobyl disaster

1998 Michel Houellebecq publishes
The Elementary Particles

2002 Euro introduced

2005 Muhammad cartoons controversy

2010 Polish president Lech Kaczyński and
many other high-ranking Polish
officials killed in plane crash

1975 1980 1985 1990 1995 2000 2005 2010 2015 2020 2025

NEO RAUCH

Neo Rauch is a master of realistic detail, and his paintings mine images from the past to suggest twenty-first-century psychological angst. Like an eccentric stage director, Rauch can arrange his painted characters in unusual and often disorienting ways.

The complex modern history of Germany is never far from Neo Rauch's enigmatic art. Rauch was born in Leipzig, East Germany in 1960, a year before the Berlin Wall was erected. He grew up in a country isolated by politics, philosophy, and military force. He also grew up in a family torn apart by tragedy. Rauch's parents—both of whom were budding art students—died in a train crash shortly after his birth and Neo was raised by grandparents.

During Rauch's childhood, East German painters continued the traditions of realism and perceptual art. Leipzig's artists, in particular, were among the more liberal-minded in East Germany. They used realism to create works that were both finely detailed and cunning in the way they explored "unacceptable" subjects. Their imagery often symbolized religious and other "anti-communist" themes. When the young Rauch began his studies at Leipzig's Academy of Visual Arts, he was able to learn from many of these artists. Rauch experimented with everything from perceptual to abstract art. But he eventually developed a style that combined the technically proficient realism of Leipzig's older generation with his own offbeat sense of composition.

Many of Rauch's early works show the influence of Pop Art, depicting figures in the manner of Western comic books and advertising posters. In *Regel (Rule)* (2000), for example, Rauch's human characters seem to have stepped out of the fifties and sixties. He even places the painting's title in a fifties-style text bubble at the top of the image. But the meaning of this work is decidedly vague. Its characters are of widely varying sizes, and they are engaged in activities that seem unrelated. The disorienting nature of this piece seems to reflect a society still coming to terms with dramatic cultural changes and the loss of traditional roles.

Other Rauch paintings experiment with more three-dimensional settings. In *Jagdzimmer (The Hunter's Room)* (2007), Rauch again depicts figures clad in fifties garb. Two male hunters, one of whom lights the other's cigarette, have a confident swagger evocative of old Hollywood films. Near them, the woman sitting at the center table pokes at a dead bird in a completely disinterested manner. Again, Rauch's work defies easy interpretation. Yet the attention to detail is striking, from the precise rendering of leather jackets and cotton slacks to the sheen on the painted wooden ceiling. All of these details give the piece an engaging theatricality, appropriate for an artist who compares himself to a director of plays.

Rauch has stated that he never knows exactly what his compositions will look like beforehand. For him, paintings should "evolve" organically during the production process. This working method sometimes results in imagery with a surrealist edge. In *Entfaltung (Unfolding)* (2008), for example, people in costumes from various eras exist in a fractured space. Stairways lead to unknown locations and disembodied hands float upon a darkened sky. The image seems reminiscent of Salvador Dali's nightmarish dreams. But Rauch's nightmare has an intentional staginess. It reminds viewers of cult horror films and other manufactured terrors of modern commercialism. *bf*

1960 Born in Leipzig, Germany
1981–86 Studies painting at the Academy of Visual Arts (HGB), Leipzig
1986–90 Master scholar at the HGB, Leipzig
1993–98 Assistant at the HGB, Leipzig
2005–9 Professorship of painting and graphic design at the HGB, Leipzig
2007 Paints a series of works especially for his solo exhibition *Para* in the mezzanine of the modern art wing at the Metropolitan Museum, New York
2010 *Neo Rauch: Begleiter* is shown at the Museum der bildenden Künste Leipzig/Pinakothek der Moderne, Munich

above
Neo Rauch, undated at HGB, Leipzig

following double page
Neo Rauch, *Kalimuna*, 2010, oil on canvas, 300 x 500 cm, Pinakothek der Moderne, Munich, Courtesy Galerie EIGEN + ART Leipzig/Berlin and David Zwirner, New York

left page
Neo Rauch, *Übertage*, 2010, oil on canvas, 300 x 250 cm, Private collection, Courtesy Galerie EIGEN + ART Leipzig/Berlin and David Zwirner, New York

1962 Cuban missile crisis

1969 Woodstock Festival in upstate New York

1920 1925 1930 1935 1940 1945 1950 1955 1960 1965 1970

Raymond Pettibon, *No Title (I Hit My)*,
2003, ink on paper, 38.1 x 48.9 cm,
Courtesy Contemporary Fine Arts, Berlin

1982 Production of first commercial
CD player

1995 *Toy Story* is first movie produced
entirely with computer animation

2002 US opens detention camp in Guantánamo

2005 Founding of YouTube

2008 Death of American director
Sydney Pollack

1975 1980 1985 1990 1995 2000 2005 2010 2015 2020 2025

RAYMOND PETTIBON

The wit of the cartoon strip and the edginess of punk rock merge in Raymond Pettibon's drawings. His subversive images comment on the preoccupations of American pop culture: sex, violence, celebrity, and anti-authoritarianism.

Raymond Ginn did not become an artist through traditional means. A precocious teenager, he graduated from university at age nineteen with a degree in economics. But Ginn would not use his talent with numbers for very long. He soon found an outlet for his other talent: drawing. Ginn became the chief artist for his brother's band, Black Flag, one of the seminal groups in punk rock history. He designed Black Flag's logo—an arrangement of four black bars—and he produced images for the band's album covers and concert fliers. Ginn also decided to change his last name to Pettibon, a variation of the nickname "Petit Bon" (good little one) that his father had given him when he was a child. In interviews, Pettibon has claimed that he abandoned the name Ginn to avoid being called "Ray Ginn," which sounded too much like Ronald "Reagan," the conservative U.S. President.

Indeed, Pettibon was never a conservative artist. His darkly humorous illustrations for Black Flag helped make the band famous. Raymond was also creating his own, more personal art—stacks of drawings that he would collect and disseminate in book form. Most of his early collections were distributed through his brother's record label, SST Records. Pettibon enlivened his black-and-white art with a fluid sense of line, and he incorporated cleverly written texts into his compositions. One drawing from the book, *Tripping Corpse #3* (1983), depicts the infamous hippie criminal Charles Manson. It shows Manson being led away from one of his murdered victims by two police officers. The caption at the top reads, "The LSD really cleared the cobwebs of up-tight, straight-world reality from my mind. I feel free for the first time in my life." Works such as this revealed Pettibon's interest in the foibles of the hippie generation, a generation he felt had been destroyed by its own false idealism.

Pettibon's art also used and reused established icons from American pop culture. Baseball players, superheroes, guns, and even Biblical figures made their appearance in his work. As with some of Pettibon's hippie imagery, many of these drawings touched upon the undercurrents of violence and sex in American life. One untitled piece from 1990 features Batman being held at gunpoint by a mysterious woman—a mock *femme fatale*. Batman's vaguely erotic thoughts are displayed in text that covers nearly half of the image. Yet this Batman is an impotent character, evoking a society more interested in self-reflection than action. Pettibon often showed greater sympathy for America's diminutive heroes. One of his favorite characters was Gumby, the surreal, human-like clay figure from fifties children's television. Pettibon discussed his attraction to Gumby: "He goes into a biography or historical book and he interacts with real figures from the past. George Washington, or whatever. And I tend to do that in my work."

Since the nineties, Pettibon has experimented with different materials, expanding his use of watercolor and other paints. His series of blue "wave" paintings from 2004 depicts the iconic beach culture of Pettibon's Southern California home. The artist has also produced large-scale wall art and animated films, enlisting new media to create his distinctively American imagery. *bf*

1957 Born in Tucson, Arizona as
Raymond Ginn
1977 Graduates from the University
of California, Los Angeles
1977 His brother Greg Ginn founds the
punk band Black Flag, for which
Pettibon designs album covers;
by this time he adopts his new
surname, from the nickname
"Petit Bon" (good little one) given
to him by his father
1990 Designs cover and booklet for the
album *Goo* by Sonic Youth
2001 Wolfgang Hahn Prize, Cologne
2002 Takes part in Documenta 11
2004 Receives the Bucksbaum Award
from the Whitney Museum of
American Art, New York
2010 Awarded the Oskar Kokoschka
Prize

Raymond Pettibon, undated

MAURIZIO CATTELAN ▬▬▬▬▬▬▬▬
DAMIEN HIRST ▬▬▬▬▬
JEFF KOONS ▬▬▬▬▬▬▬▬▬▬▬▬

1962–65 2nd Vatican Council

1920 1925 1930 1935 1940 1945 1950 1955 1960 1965 1970

Maurizio Cattelan, *La rivoluzione siamo noi*, 2000,
Polyester resin figure, felt suit and metal coat rack, puppet:
124.9 x 32.06 x 23 cm, wardrobe rack: 188.4 x 46.9 x 52 cm,
Courtesy of the artist and Marian Goodman Gallery, New York

1971 Women's suffrage introduced
in Switzerland

1983 Discovery of the AIDS
virus, HIV

1991 Conflict breaks out in the Balkans

2000 Dot-com bubble bursts

2004 EU expands eastward

2009 Major earthquake in L'Aquila, Italy kills
300 and leaves thousands homeless

1975 1980 1985 1990 1995 2000 2005 2010 2015 2020 2025

MAURIZIO CATTELAN

Cattelan's sculptures poke fun at the iconic symbols of his own Italian heritage. Sleek stallions and balding popes are presented with an eye for humor and satire—and to explore larger cultural themes.

Maurizio Cattelan places his images in space. "Every time I start a new piece I consider a space," he says, "a precise location where it will be located.... It intrigues me how there is only one solution for each space, one single answer that works." These solutions often humorously strip his images of their normal meanings.

Cattelan came to art relatively late in life, shifting from furniture design to sculpture in his twenties. The artist's work soon captured public attention with its overt wit, but it also provoked more complex interpretations. Cattelan's famous 1996 sculpture, *The Ballad of Trotsky*, featured a taxidermied horse hanging from the ceiling by a saddle. The exhibit cleverly "switched" the function of the saddle from a device for holding up a rider to one for holding up a horse. It also questioned the traditional function of equestrian art as a means of promoting human power and authority. Even the work's title brought to mind the failures of communism and other grandiose attempts at social construction. Cattelan produced other works combining nature and visual puns. An untitled piece from 1998 featured a tree growing on top of a cubic mound of dirt, its roots hidden inside the mound. The geometrical form of the dirt made it resemble a giant gift box from which the tree was being extracted. Thus an ancient symbol of renewal and eternal life had become associated with the less eternal values of modern capitalism.

Cattelan brought similar humor and complexity to his human images. One of his most famous works, *La Nona Ora (The Ninth Hour)* (1999), showed a figure of Pope John Paul II being struck to the ground by a meteorite. On the surface, the image appeared to mock the Catholic Church and its modern-day struggles with secular culture. But Cattelan had a different, more expansive interpretation. "I don't think it was a provocation," he said, "and certainly not anti-Catholic.... The pope is more a way of reminding us that power, whatever power, has an

expiration date, just like milk." This desire to assess the power behind cultural icons also came out in Cattelan's "portrait" of Adolf Hitler, one of a series of exhibits called *HIM* (2001). Here the artist showed Hitler kneeling like an alter boy at church. Even Hitler's body was shrunk to the size of a boy's, while his head remained adult-sized. Cattelan also structured the exhibit so that the viewer would see only the back of the figure at first. Thus the initial impression of the sculpture would be transformed once the viewer saw its face. Cattelan saw this piece as an effort at "peeling off masks and roles."

During recent years, the artist's work has continued to provoke debate. In *L.O.V.E.* (2010), Cattelan temporarily placed a monumental, Renaissance-style hand in front of the Milan Stock Exchange. The hand gestures offensively, with its middle finger raised. Yet is this work merely a "cheap publicity stunt," a childish insult aimed at a troubled financial industry? Or is the artist making a larger comment about the need to reject insensitive authority figures—especially in a country with a history of Fascist leadership? Cattelan has said that people can "read between the lines and take away the message they see for themselves." *bf*

1960 Born in Padua, Italy
1993 Takes part in the 45th Venice
Biennale
2000 Nominated for the Guggenheim's
Hugo Boss Prize
2005 Awarded the Arnold Bode Prize
from the Kunstverein Kassel,
Germany
2006 Co-curator with Massimiliano
Gioni and Ali Subotnick,
4th Berlin Biennial for Contemporary Art

Maurizio Cattelan, undated

left page
Maurizio Cattelan, *Frank and Jamie*,
2002, wax and clothes,
Jamie: 182.2 x 62.8 x 45.7 cm,
Frank: 191.7 x 63.5 x 52.7 cm,
Courtesy of the artist and Marian
Goodman Gallery, New York

below
Maurizio Cattelan, *Untitled*, 2009,
horse skin, fiberglass and resin,
life size, Courtesy of the artist and
Marian Goodman Gallery, New York

1963 Bob Dylan records
"Blowin' in the Wind"

1920 1925 1930 1935 1940 1945 1950 1955 1960 1965 1970

Tracey Moffatt, *Something More #3*,
1989, series of 9 images, Cibachrome,
98 × 127 cm, Courtesy the artist and
Roslyn Oxley9 Gallery, Sydney

1973 Chilean president
Salvador Allende
overthrown

1983 Production of the
first commercial
mobile phone

1994 Tutsi genocide
in Rwanda

2004–9 Construction of the Burj Dubai

2001 9/11 Islamic terrorist
attacks

1976 First G7 summit

1991 World Wide Web (WWW)
cleared for general use

1975 1980 1985 1990 1995 2000 2005 2010 2015 2020 2025

TRACEY MOFFATT

Humor and tragedy are never far apart in Tracey Moffatt's photography and films. The artist incorporates a variety of imagery—from the harsh landscapes of her Australian home to the humorous artificiality of pulp films—to convey themes of dislocation and sexual desire. She also examines the role of the artist in a multicultural society.

Tracey Moffatt grew up in Australia in the sixties, an era saturated with Disney movies and images from *Life* magazine. Yet she also grew up as an Aboriginal child in a white foster home, a part of the "lost generation" that had been separated from their Aboriginal parents. This complex personal history, and the sense of dislocation that it engendered, has often influenced the choice of subject matter in her art.

Moffatt's breakthrough work, *Something More* (1989), consisted of nine photographs meant to be viewed chronologically, like a storyboard. Moffatt herself played the story's tragic heroine, a "colored" woman seeking to flee her cruel white foster parents and find "something more." The photos revealed oblique details of her daring escape and her capture by racist police, and the story ends with a shot of her dead body lying on the road. This overt artificiality was enhanced by the work's Hollywood-style painted backdrops, as well as the melodramatic "performances" from Moffatt and the other actors. Yet behind the campy drama, *Something More* probed the emotional conflicts that underlie the human struggle for independence.

In her *Up in the Sky* series (1997), Moffatt presented the "lost generation" story in a larger series of photographs. She again utilized the talents of actors, but her settings now eschewed artificial backdrops. *Up in the Sky* was photographed in the barren, black-and-white world of the Queensland outback. The story focused on a poor rural town and the toxic web of relationships that played out there between whites and Aborigines. Moffatt's images now had a gritty look, complete with rustic shacks and shabbily clothed townsfolk. They gave her Australian story a more universal character— evoking memories of other iconic periods of hardship, including the 1930s Dust Bowl in the United States.

Moffatt used a different way of mixing humor and tragedy in *Scarred for Life* (1994). Here the artist created lithographs that resembled magazine pages, combining images from everyday life with dated captions. The images suggested sexual humiliation, child abuse, and other dark themes; but the captions treated these themes in a witty manner. One of the images, titled *The Wizard of Oz*, 1956, shows a father seated next to a young boy in a girl's costume. The caption reads, "He was playing Dorothy in the school's production of the *Wizard of Oz*. His father got angry at him for getting dressed too early."

Moffatt also translated her love of storytelling to the medium of film. In *Night Cries: A Rural Tragedy* (1989), she incorporated several of the visual elements from her photographs. Scenes of Aboriginal foster children at the beach were interspersed with depictions of poverty-stricken rural life. Also included were clips of the Aboriginal country singer Jimmy Little, an ironic symbol of Aboriginal assimilation. Here again, Moffatt attempted to universalize the difficult search for identity— suggesting connections between the struggles of all marginalized groups. *bf*

1960 Born in Brisbane, Australia
1982 Graduates from Queensland College of Art
1993 Her film *Bedevil* is presented at the Cannes International Film Festival
2001 Her series *Fourth* uses images of athletes from the 2000 Summer Olympic Games in Sydney who came in fourth in their various competitions
2007 Creates the film *Doomed* in collaboration with Gary Hillberg

Tracey Moffatt, undated

Takashi Murakami, Installation view
of © MURAKAMI at the Geffen
Contemporary, The Museum of
Contemporary Art, Los Angeles, 2007
Artworks: *Superflat Jellyfish Eyes 2* (2003,
left), *Tongari-kun* (2003–4, center),
Kawaii! Vacances d'été (2002, right)

1973 First commercial
personal computer

1990 34 CSCE states declare
the Cold War over

2004 Catastrophic floods in Asia

1978 The Galápagos Islands are the first item
on the UNESCO World Heritage list

1997 UN climate conference
concludes in Kyoto Protocol

2010 Expo in Shanghai

| 1975 | 1980 | 1985 | 1990 | 1995 | 2000 | 2005 | 2010 | 2015 | 2020 | 2025 |

TAKASHI MURAKAMI

Murakami is both an artist and a businessman. His "superflat" images incorporate the candy-colored, big-eyed figures from Japanese anime and manga. Murakami has also courted the commercial world—producing lines of Louis Vuitton handbags and other products that stretch the definition of art.

Throughout his career, Takashi Murakami has worked to develop a distinctly Japanese form of modern art. While at the Tokyo National University of Fine Arts and Music (now the Tokyo University of the Arts), Murakami studied nineteenth-century *nihonga* painting—a combination of traditional Japanese and Western techniques. But he soon developed a style that drew from more contemporary, homegrown aspects of his native culture.

Murakami is fascinated by Japan's *otaku* subculture, a culture obsessed with the objects of science fiction and cult fantasy. Otaku objects often include manga comics and anime films, both known for their extremely two-dimensional characters and landscapes. Murakami has called the otaku a "discriminated" people in his country, a people often falsely associated with dangerous cults. The artist also sees otaku as representing the insular qualities of Japanese culture as a whole. Japan is "a closed world with no way out," he has said, and otaku "have to live in a fantasy." So Murakami has absorbed otaku imagery into his art, exaggerating its two-dimensional quality and creating a style called "superflat." Murakami has also helped develop the marketing term *poku* to describe his art's combination of "pop" culture sensibility and "otaku" themes.

In his paintings and prints, Murakami often isolates a disembodied superflat head in abstract space or arranges multiple heads into decorative patterns. The painting *And Then, And Then And Then And Then And Then* (1994) presents one of the artist's stock characters: Mr. DOB (Mr. "Why"). Mr. DOB's face combines the wide-eyed stare of anime, the mouse-like ears of Walt Disney characters, and stylized details from Murakami's own face. In the silkscreen print *Puka Puka* (1999), surreal head-like shapes with multiple eyes and mouths fall like raindrops through a bright yellow backdrop. The visual forms of both *And Then* and *Puka Puka* reflect the superficiality of consumer culture. Even the works' titles suggest the repetitive nature of industrial products, and the repetitive habits of the people who buy them.

Murakami's sculptures also embody his superflat "ideal." The fiberglass statue *Miss ko2* (1996) is a fetishized blonde waitress with large breasts, long legs, and skimpy clothing. She seems to represent the commercial ideal of beauty, yet her sensuality is compromised by her blank, superflat eyes and awkward pose. In 2010, *Miss ko2* and other Murakami sculptures made their appearance at France's Palace of Versailles. Some of the works, including the elaborately painted *Tongari-Kun (Mr. Pointy)* (2003–4), displayed a baroque decorative quality that both reflected and parodied their sumptuous surroundings. This decorative style has also proven popular in the commercial world. Murakami has long promoted the value of artists in shaping popular tastes, and he has collaborated with Louis Vuitton and other manufacturers to create his own brand-name merchandise. Murakami shoes, bags, telephones, and other goods proliferate worldwide in stores and on the Internet.

Recently, Murakami has begun to produce art inspired by the traditional Japanese culture that he studied at university. A 2008 exhibit presented several self-portraits resembling Buddhist prints, as well as stylized versions of Japanese landscapes. Yet these works also retained the some of the artist's superflat styling—and his continuing interest in making international art with a Japanese face. *bf*

1962 Born in Tokyo, Japan
1986–88 Studies at the Tokyo National University of Fine Arts and Music
1993 PhD at the Tokyo National University of Fine Arts and Music
1996 Foundation of the Hiropan Factory in Tokyo, which evolves into Kaikai Kiki Co. in 2001
1998 Visiting Professor at the School of Art and Architecture, UCLA, Los Angeles
2000 Curator of the exhibition *Superflat* at the Parco Department Store Gallery in Shibuya, Tokyo
2003 Designs the Monogram Multicolore Series for the French label Louis Vuitton
2005 Awarded the Japan Society Imajiné Award
2007 Cover design for Kanye West's single "Stronger" and the album *Graduation*
2010 *Murakami Versailles* is shown at the Palace of Versailles, Paris

Takashi Murakami, undated

1963 *New Figuration* exhibition
in Florence

1971 Women's
suffrage int
duced in
Switzerlanc

1920 1925 1930 1935 1940 1945 1950 1955 1960 1965 1970

Pipilotti Rist, *Liberty Statue
for Löndön* (monolith version),
2005/8, audio-video
installation, installation view:
Art Unlimited, Basel, 2008

1980 First Alternative Nobel Prize
awarded in Stockholm

1990 German reunification

1995–99 Power station converted into
the Tate Modern in London

2002 Euro introduced

2009 General Motors declares bankruptcy

2006 Montenegro declares independence from Serbia

2010 Volcanic ash from Iceland causes
havoc on European air space

1975 1980 1985 1990 1995 2000 2005 2010 2015 2020 2025

PIPILOTTI RIST

"Video is like a compact handbag; everything from literature to art and music is in it," asserts Swiss artist Pipilotti Rist. And she manages to fit her art into a wide range of formats, whether it means putting a monitor inside a schnapps bottle or mounting a large installation in the atrium of New York's Museum of Modern Art.

While working with performance and pop music as a member of music group Les Reines Prochaines, Pipilotti Rist focused on videos and video installations in the late eighties for her artistic production. In 1992, she gained an international reputation with the film short *Pickelporno*. The camera tracks the physical coupling of lovers—their bodies intertwined, their gentle caresses—and translates sensual impressions into various natural motifs such as flowers, clouds, and volcanic lava.

All nice and colorful here

Sexuality, eroticism, physicality, oneness with nature, and the longing for cosmic union are recurring themes in her works. A colorful rush of sensual images is paired with musical elements; visual distortions and superimpositions, bleach-outs and solarizations conjure up dream worlds, evoking states of intoxication. We see the materialization of Rist's utopias in which she attempts, through positively focused works, to bring about human and cultural progress and recapture the spontaneity of children. Among her insouciant and humorous works is *Ever is Over All*, a video in the collection of the Museum of Modern Art in New York, and which won an award at the Venice Biennale in 1997. In the video, a young woman cheerfully walks along the street holding a flower with which she thrashes the windows of parked cars. A female cop benignly watches her destructive pastime.

In her first feature film *Pepperminta*, which reached theaters in 2009, the eponymous heroine aims to liberate the Earth and its inhabitants from their fears and compulsions. Pepperminta—clearly an untamed sister of Pippilotta Viktualia Rullgardina Krusmynta Efraimsdotter Långstrump (Pippi Longstocking)—hypnotizes people with colors in order to create a new world. As in her video installations, the director chooses bold camera angles, inverts vertical orientation, zooms into nostrils, or has the audience flying through tulip fields, encouraging them to adopt a more intense relationship with life.

Art stations

Rist's real first names are Elisabeth Charlotte. Her friends called her Pipi, her family Lotti, and thus her professional name came ready-made. Pipilotti initially studied at the University of Applied Arts Vienna before taking a video course at the Basel School of Design. In 1997, she was the artistic director of the Swiss national exhibition Expo.01, and the same year was awarded the Duemila Prize at the 47th Venice Biennale. In 2004, she won the 01 Award for extraordinary artistic achievements in the field of multimedia and was made an honorary professor at the Berlin University of the Arts. Pipilotti Rist lives in Zurich and the Swiss mountains. cw

1962 Born Elisabeth Charlotte Rist in
Grabs, Switzerland
1982 Becomes a student at the
University of Applied Art in
Vienna
1986 Enrolls at the Basel School of
Design; first video, audio works,
and installations
1988 Becomes a member of the band
Les Reines Prochaines (until 1994)
1999 Takes part in the 48th Venice
Biennale
2002–3 Paul McCarthy invites her to
teach at UCLA
2009 Opening of her motion picture
Pepperminta

Pipilotti Rist, 2008

GABRIEL OROZCO ▬▬▬▬▬▬▬▬

AI WEIWEI ▬▬▬▬▬▬▬▬▬▬▬▬▬▬

RAYMOND PETTIBON ▬▬▬▬▬▬▬▬▬▬

1969 Richard Nix
sworn in as
the 37th US
president

1962 Cuban missile
crisis

| 1920 | 1925 | 1930 | 1935 | 1940 | 1945 | 1950 | 1955 | 1960 | 1965 | 1970 |

Gabriel Orozco, installation view, 2008; on
the wall: *Tuttifruti*, 2008, tempera and gold
leaf on canvas, 200 x 200 x 3.8 cm; on the
pedestal: *Tronco 3*, 2008, tempera and gold
leaf on wood, 91.2 x 29.5 x 14.9 cm, *Tronco
Verde*, 2008, tempera and gold leaf on wood,
91 x 21 x 14 cm, *Tronco 2*, 2008, tempera and
gold leaf on wood, 89 x 28 x 15 cm, Courtesy
Marian Goodman Gallery, New York

1977 Walter De Maria installs *The Lightning Field* near Quemada, New Mexico

1991 Soviet Union breaks up

2005 Hurricane Katrina devastates New Orleans

1998 Construction of International Space Station (ISS) begins

2009 Swine flu epidemic

1975 1980 1985 1990 1995 2000 2005 2010 2015 2020 2025

GABRIEL OROZCO

Orozco's art finds the poetic side of everyday objects, sometimes by taking them apart and rebuilding them in surprising ways. Like the Mexican muralists of the early twentieth century, Orozco uses his imagery to question and reshape cultural attitudes.

Gabriel Orozco's father, Mario Orozco Rivera, introduced his son to the world of Mexican art. Rivera worked for years with muralist David Siqueiros, whose politically charged scenes captured the struggles of ancient and modern Mexico. Siqueiros created novel techniques for distorting visual perspective, forcing the viewer to interpret his subjects in new ways. Young Gabriel, too, would find ways of incorporating distortions into his work.

Unlike Siqueiros, however, Orozco would not focus on one medium or style. Like many conceptual artists of his generation, he would explore sculpture, painting, photography, and video. He would also absorb the cultures of different countries, travelling extensively and setting up homes in Paris, New York City, and Mexico City.

From the beginning of his career, Orozco became famous for installations that transformed ordinary objects. In *La DS* (1993), the artist presented a Citroën DS automobile that had been cut into three horizontal sections and then reattached using only the outer two pieces. The resulting sculpture could be seen in different ways depending on the angle from which one viewed it. Seen partially from the side, the car's "slimmed down" body looked sleek and elegant. But if viewed directly from the front or back, it appeared squashed and almost comical. Orozco's mutilated Citroën probed issues of identity and image, evoking the "distortions" that excessive plastic surgery can inflict on people who seek the "perfect look."

Another famous early work, *My Hands are My Heart* (1991), addressed the human body more directly. This piece featured two photographs of the artist holding a heart-shape lump of clay against his bare torso. The heart had been made by the artist and showed the indentations of his fingers. When placed against Orozco's body, the sculpture appeared to blend seamlessly into his torso—its indentations looking almost like impressions of ribs. Here Orozco emphasized the importance of the body as inspiration for art. This theme reoccurred in the artist's elaborate series of handprints called *Fear Not* (2001). Pens, scissors, and colored paints were used to transform the prints into elegant collages, some of which had the look of modernist stained glass windows.

Orozco has also created art exploring human perceptions of nature. In *Ping Pond Table* (1998), he arranged four hemispherical table pieces around a small lily pond. The four sides of the green table resembled abstract leaves, reminiscent of the plants they enveloped. Ping-pong paddles and balls were placed on the table, and viewers were invited to become a physical part of the artwork—a gesture that raised questions about human involvement in the natural world. A more recent Orozco installation probed similar ideas in a far more dramatic way. *Mobile Matrix* (2006), one of the artist's grandest sculptures to date, features an entire whale skeleton covered in graphite markings. Orozco and his team had recovered the skeleton from a dead whale beached in Baja California. The team then worked with scientists to treat the whale bones and painstakingly reconstruct the skeleton. Thousands of mechanical pencil leads were used to decorate the piece, which now hangs in Mexico City's José Vasconcelos Library. Orozco has compared his whale to a giant machine, and he described the markings as revealing the skeleton's "movement and functionality." Here again, the artist had merged artistic ideas, human craftsmanship, and organic materials. *bf*

1962 Born in Xalapa, Veracruz, Mexico

1981–84 Studies at the Escuela Nacional de Artes Plásticas (ENAP) and the Academia de San Carlos, Mexico City

1986–87 Studies at the Círculo de Bellas Artes, Madrid

1993 Participates in the 45th Venice Biennale

1997 Takes part in Documenta X

2002 Takes part in Documenta 11

2009–10 The Museum of Modern Art, New York presents the retrospective *Gabriel Orozco*

Gabriel Orozco, undated

Gabriel Orozco, *Round Mirror Distance*,
2001, silver dye bleach print,
40.6 x 50.8 cm, Courtesy of the artist
and Marian Goodman Gallery, New York

Gabriel Orozco, *Juego de Limones*, 2001,
silver dye bleach print, 40.6 x 50.8 cm,
Courtesy of the artist and Marian Good-
man Gallery, New York

1961 Founding of Amnesty
International

1970 British ro
band Que
forms

1920	1925	1930	1935	1940	1945	1950	1955	1960	1965	1970

Tracey Emin, *My Bed*, installation,
Turner Prize exhibition, October 20,
1999–January 23, 2000, Tate Gallery,
London

1975 Pol Pot comes to power in Cambodia

1985 Mikhail Gorbachev becomes Party Secretary in the USSR

1995 Tamagotchi electronic pet introduced in Japan

2001 *Pop Idols* launches the TV casting-show format

2004 Islamist terrorist attacks in Spain (11th March)

2010 Researchers at the Westfälische Wilhelms University discover signs of water on Mars

1975 1980 1985 1990 1995 2000 2005 2010 2015 2020 2025

ZHANG HUAN

For Zhang Huan, endurance is a key virtue of art. In his performance works, he puts his body through stress to highlight the human suffering in his native China. His sculptures and photographs also focus on the harsh yet enduring nature of grassroots Chinese society.

Zhang Huan makes art out of challenge. His performances—as well as his sculptures—challenge both the stamina of his own body and the policies of his country's government. Zhang first gained prominence in the nineties as a member of the Beijing East Village. This artistic commune transformed a rundown Beijing housing development into a hotbed of radical Chinese art—much like the bohemian artists in New York City had transformed their own "East Village" in the sixties. In one of Zhang's first performances, *12 Square Meters* (1994), he sat naked for an hour in a public toilet, his body covered in honey and fish oil and attracting flies. For many, this work spoke to the endurance of poor Chinese city residents in filthy living conditions. Zhang explained that the work was inspired by a local toilet where the "village heads used to go," but where he now found "thousands of flies that seemed to have been disturbed by (his) appearance."

Zhang soon began bringing his art to other countries. For a performance in Japan, *3006m³:65kg* (1997), he used hundreds of medical tubes to attach his naked body to an antique, two-wheeled axle. This painful-looking contraption was also attached to a wall of Tokyo's Watari Museum of Contemporary Art. Zhang's performance involved physically pushing the wheels and tubes away from the wall, as if to pull the museum down with his body. The work highlighted the contradictory and often hostile relationship between the artist and the art establishment.

Zhang's performances were also captured in photographic series. *Foam* (1998) presented fifteen images of Zhang's face covered in foamy soap. In each photo, the artist held a different family portrait in his open mouth. The tiny portraits seemed to be emerging from the artist's mouth, reminiscent of ancient deities emerging from ocean waves. *Foam* emphasized the continuing significance of family and ancestry in Chinese culture.

Since 2005, Zhang has moved away from performance art as a medium of expression, using other methods to examine his culture-related themes. His *Seeds* images from 2007 replicated black-and-white photographs of workers toiling on collective farms during the Maoist era. Each of these works was produced as an elaborate "mosaic" made up of tiny pieces of Chinese incense ash. Zhang's laborious art-making process paid homage to the backbreaking work depicted in the images. The artist also produced several sculptures that touch upon China's Buddhist history, a heritage often repressed by his country's government. In one example, *Long Ear Ash Head* (2007), Zhang created his own piece of Chinese archaeological history—a fragmented Buddha-style head. The work featured only the top portion of the head, down to the bottom of the nose. The top of the skull was separated from the rest of the piece and raised slightly above it, while the long ears extended down to the ground—with the lobes forming foot-like extensions. Zhang's image effectively reproduced the calm, reflective nature of antique statuary. It also suggested the artist's desire to recover fragments of China's dying religious traditions. *bf*

1965 Born in Anyang, China
1988 Graduates from Henan University, Kaifeng
1993 Graduates from the Central Academy of Fine Arts, Beijing
1999 Takes part in the 48th Venice Biennale
2002 Participates in the Whitney Biennial, New York
2009 Stages Georg Friedrich Handel's opera *Semele* at the Théâtre Royal de La Monnaie, Brussels

Zhang Huan, undated

below
Zhang Huan, *My Boston*, 2005,
performance, Museum of Fine Arts,
Boston

right page
Zhang Huan, *Long Ear Ash Head*, 2007,
ash, steel and wood, 370 x 400 x 338 cm

1965 First Op Art exhibition, *The Responsive Eye*, in New York

1971 First Starbucks opens

1920　　1925　　1930　　1935　　1940　　1945　　1950　　1955　　1960　　1965　　1970

1981 First space shuttle (Columbia)

1990–91 Persian Gulf War

2006 Jackson Pollock's *No. 5* sold for $140m

1998 Lewinsky affair makes the headlines

2009 Barack Obama awarded Nobel Peace Prize

1975 1980 1985 1990 1995 2000 2005 2010 2015 2020 2025

ELIZABETH PEYTON

Born in Connecticut in 1965, Elizabeth Peyton is one of a small number of young artists who, in spite of contemporary tastes and the controversy about abstraction and formal innovation, rediscovered figurative painting at the end of the twentieth century. Her work is remarkably consistent, and represents a kind of popular realism that exercised considerable influence on contemporary art in the United States and Europe in the mid-nineties.

Peyton's subject is the portrait—both historical personages and contemporary cultural icons feature in her paintings. In 1996, she began to portray close friends, artists, writers, musicians, and DJs from New York, London, and Berlin. What mattered to the artist was "how influential some people are in others' lives. So it doesn't matter who they are or how famous they are but rather how beautiful is the way they live their lives and how inspiring they are for other people."

In addition to Marie Antoinette, Napoleon, and Ludwig II of Bavaria, figures that caught the painter's attention include Frida Kahlo, Leonardo DiCaprio, Pete Doherty, and Oscar Wilde. She produces her generally small-format oil paintings, watercolors, and drawings from her own photos, pictures from magazines, CD covers, and video stills, or after reading and interpreting biographies and novels. Far from simply reproducing what she sees and reads or lauding celebrities, Peyton attempts to pierce the impersonal element of her subjects and get close to the person. Her works, which generally bear the subject's first name, display a high degree of emotionalism. They come across as both real and idealized, subjects of yearning, telling of a quest for the human and the beautiful. The subjects often appear fragile and delicate, with light eyes, pale skin, and gleaming red lips, giving them an androgynous appearance.

Melancholy

The themes of the young and the promise of youth run through Peyton's oeuvre—for example, when she paints David Hockney as a young rebel or Kurt Cobain as a budding genius before he became world-famous as the singer and guitarist of Nirvana. Cobain's portrait is not the only work that speaks of happiness and sorrow. Her portraits of Diana Spencer and Elvis Presley, who both spent major portions of their lives in the public eye only to die tragically, are pictures of great promise and tragic failure.

Peyton at first exhibited in unconventional places such as hotels or private sitting rooms, but today her work is widely known. In 2004, the artist began to paint from life in her Manhattan studio. cw

1965 Born in Danbury, Connecticut
1984–87 Studies at the School of Visual Arts, New York
1987 First exhibition at the Althea Viafora Gallery, New York
2008 The New Museum of Contemporary Art, New York shows the retrospective *Live Forever*
2009 *Blood of Two*, performance in collaboration with Matthew Barney on the Greek island of Hydra

left page
Elizabeth Peyton, *Patti and Robert*, NYC, 2009–10, oil on board, 31 x 23 cm, Courtesy neugerriemschneider, Berlin

above
Elizabeth Peyton, *E*, 2010, charcoal on paper, 28.9 x 21 cm, Courtesy neugerriemschneider, Berlin

1966–73 Construction of
the World Trade
Center in New York

1920 1925 1930 1935 1940 1945 1950 1955 1960 1965 1970

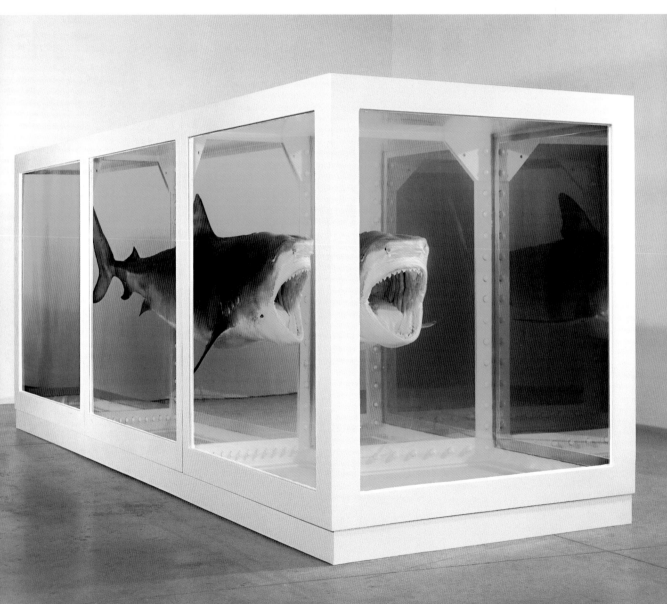

Damien Hirst, *The Physical Impossibility
of Death in the Mind of Someone Living*,
1991, tiger shark, glass, steel and form-
aldehyde solution, 213 x 518 x 213 cm,
Saatchi Collection, London

1976 Helmut Newton publishes his
first book *White Women*

1988 Freeze exhibition in London
launches Young British Artists

1995 Peace agreement between Israel
and the PLO signed in Oslo

2001 The war in Afghanistan
begins

2006 Fidel Castro cedes power to
his brother Raúl

2010 Degas's painting *Les Choristes* stolen
from a museum in Marseilles

1975 1980 1985 1990 1995 2000 2005 2010 2015 2020 2025

DAMIEN HIRST

The art of Damien Hirst is often preoccupied with death and degeneration. Yet Hirst has lived his own life with unceasing energy. He became the best known of all contemporary British artists, and he helped boost his country's place in the international art world.

Damien Hirst has always invited controversy. His installations can reveal shocking and "distasteful" imagery. His production methods make people question whether he creates his own art, or simply relies on the work of assistants. His popularity has earned him millions of pounds and the envy of many. Yet there is no denying Hirst's role in fueling the engine of the modern British art scene.

Damien grew up in an England obsessed with the Sex Pistols and the rising counterculture. As a student at Goldsmiths' College of Art in London, he began making his own mark in British life. Hirst helped organize the *Freeze* exhibition of 1988, which involved many individuals who would become part of the Young British Artists group. Freeze attracted the attention of London's most influential art patrons, including Charles Saatchi.

Over the next few years, Hirst would exhibit the installations that made him famous. Works such as *A Thousand Years* (1990), *The Physical Impossibility of Death in the Mind of Someone Living* (1991), and *Away from the Flock* (1993) all featured dead animals preserved in formaldehyde and displayed in glass cases. *The Prodigal Son* (1994) increased the shock value even further by presenting a dead calf split in two, with each half preserved in separate tanks. The brutal honesty of these works questioned certain practices of industrial society—from livestock confinement on large-scale "factory" farms to animal testing in research laboratories. The images also raised issues surrounding human mortality.

Charles Saatchi was immediately impressed by Hirst's animal installations, and he became one of the artist's key patrons. This influential support—as well as the controversial nature of his exhibits— quickly made Hirst one of Britain's most prominent celebrities. The artist relished his popularity, and he accumulated an army of assistants to help him realize his ideas. Hirst developed the concept of the "spot painting," which took form in such works as *Controlled Substances Key Painting, Spot 4A*. These

images featured a grid of differently colored spots, which Hirst described as a "scientific approach to painting in a similar way to the drug companies' scientific approach to life." He also devised a method of making "spin paintings" by applying paint on a spinning canvas, as in *Beautiful C Painting* (1996). The fact that most of the spot and spin paintings under Hirst's name were produced by assistants has angered some critics. Yet Damien often credits his assistants publicly, and many of them have gone on to successful art careers.

In recent years, Hirst's controversial image has softened; and he has received commissions for substantial public artworks. Castings of his most prominent outdoor sculpture, *Virgin Mother* (2005), stand in front of the Lever House in New York City and the Royal Academy of Arts in London. This huge bronze effigy exposes the inside of a pregnant woman's torso, including her womb and embryonic baby. Such imagery hearkens back to the encased animals of Hirst's early career, but without their underlying messages of death and decay. The work's title also comments on the decreasing power of religion in modern society. Mary, the Virgin Mother of the Bible, has been replaced by a virgin mother of secular culture. bf

1965 Born in Bristol, England
1986–89 Studies at Goldsmiths'
College, London
1988 Curates the *Freeze* exhibition
1991 First solo show at the Woodstock
Street Gallery, London
1992 Takes part in the first *Young
British Artists* exhibition at the
Saatchi Gallery, London with
A Thousand Years and *The Physical
Impossibility of Death in the Mind
of Someone Living*
1995 Awarded the Turner Prize
1998 Publication of his autobiography
*I Want to Spend the Rest of My
Life Everywhere, with Everyone,
One to One, Always, Forever, Now*
2000 His show *Theories, Models,
Methods, Approaches, Assump-
tions, Results and Findings* opens
at Gagosian Gallery, New York
2007 His work *For the Love of God*,
consisting of a platinum cast of
a human skull encrusted with
flawless diamonds, is sold for
£50 million

Damien Hirst in his studio in Chalford,
England, September 2006

1966 The Curia abolishes
the Index of
Prohibited Books
instituted

| 1920 | 1925 | 1930 | 1935 | 1940 | 1945 | 1950 | 1955 | 1960 | 1965 | 1970 |

Jake & Dinos Chapman, *Hell*, 1999–2000,
Glass-fiber, plastic and mixed media
(Nine parts), Courtesy White Cube,
London

1976 Apple Computers founded

in 1559

1979 Saddam Hussein comes to power
1991 Boris Yeltsin is first democratically
elected president of Russia
1995–99 Power station converted into
the Tate Modern in London to

designs by Herzog & de
Meuron
2004 Islamist terrorist attacks in
Spain (March 11)

1975 1980 1985 1990 1995 2000 2005 2010 2015 2020 2025

JAKE & DINOS CHAPMAN

The Chapman brothers came to the public's attention in the 1990s under the Young British Artist tag, and today are major figures in contemporary installation art. At its core, their oeuvre—works that are often shockingly graphic— deals with human experiences and moral behavior.

Jake and Dinos Chapman were nominated for the Turner Prize, they have had exhibitions at MoMA in New York and the Tate Britain, and their works have been acquired by major collections, and yet they continue to provoke heated controversy. They became famous for their life-size sculptures of naked children in gym shoes, with bodies grown together, and penises, vulvas, or anuses taking the place of noses, ears, and mouths. Yet works such as *Zygotic Acceleration, Biogenetic, De-sublimated Libidinal Model* of 1995, consisting of a ring of shop window manne- quins fused together, are not simply about provo- cation. The Chapmans tackle subjects such as genetic engineering, violence, and war, with the intention of showing people what they have long grown accustomed to and thus trigger "absolute moral panic."

Hell on Earth
The duo's magnum opus is their version of hell on Earth. An installation of vitrines arranged in the form of a swastika features masses of tiny figures, many in Nazi uniform, illustrating every human atrocity one might possibly imagine. The miniature beings—including mutated creatures with extra limbs and several heads—torture, mutilate, battle, rape, and leave mass graves. When *Hell* (2004) was destroyed in a warehouse fire, the Chapmans pro- duced a new version called *Fucking Hell*, unveiling it in their exhibition *If Hitler Had Been a Hippy How Happy Would We Be* in London in 2008.

(Un)touchable
A source of inspiration for many of their works is Goya's etching series *Los Desastres de la Guerra* (1810–20), in which the Spanish painter depicted the atrocities of the Napoleonic occupation of Spain. In 1993, the Chapmans translated the torture and murder depicted in the etchings into miniature sculptures, faithful down to the very last detail. Ten years later, they "rectified" a series of Goya's etchings printed from the original plates, describing *Insult to Injury* of 2003 as "Goya reworked and improved." The heads of the martyrs are painted over with clown faces to sharpen the message of the etchings and give them a sardonic update.

The Chapman brothers began their careers while studying at the Royal College of Art as assistants to Gilbert & George, the inseparable artist duo that proved so influential on the Young British Artists. In 1992, the brothers proclaimed their own arrival on the scene as an independent duo with their aesthetic manifesto *We Are Artists*. cw

1962 Dinos Chapman is born in
London, England
1966 Jake Chapman is born in
Cheltenham, England
1990 Both graduate from the London
Royal College of Art and start
working as assistants for Gilbert
& George
IN 1992 They start working on their
own corporate projects
1997 Take part in the exhibition
Sensation of the Young British
Artists at the Royal Academy
of Art, London
2003 Nominated for the Turner Prize
2007 Solo exhibition *When Humans
Walked the Earth* at Tate Britain,
London

Jake and Dinos Chapman, undated

1968 Premiere of
Stanley Kubrick
*2001: A Space
Odyssey*

1920 1925 1930 1935 1940 1945 1950 1955 1960 1965 1970

Olafur Eliasson, *Beauty*, 1993, installation
view *Minding the World*, ARoS Aarhus
Kunstmuseum, 2004

1983 Discovery of the AIDS virus, HIV	**1999** Columbine High School massacre	**2010** Largest art heist in history at the Museum of Modern Art in Paris
1977–80 Cindy Sherman produces *Untitled Film Stills*	**1992** Maastricht Treaty establishes the EU	**2004** Murder of Dutch film director Theo van Gogh

1975	1980	1985	1990	1995	2000	2005	2010	2015	2020	2025

OLAFUR ELIASSON

Working with the elements is the hallmark of Olafur Eliasson. He plays with reality and perception, light and shadow, water, colors, mist, and reflections. His installations, photos, and architectural projects move at the intersection of art, nature, and scientific research.

Olafur Eliasson was born to Icelandic parents in Copenhagen in 1967. Towards the end of his student days at the Royal Danish Academy of Fine Arts, he made the acquaintance of gallery owners Tim Neuger and Burkhard Riemschneider, and began his career with an exhibition in a rundown backyard in Cologne. Using a hose with holes in it and a lamp, he created a rainbow, one of his first small optical spectacles (*Beauty*, 1993). His contacts took him to Berlin, where he founded Studio Olafur Eliasson as an experimental laboratory for spatial exploration. Today, the studio has a staff of around thirty-five—architects, designers, art historians, and various technical experts—busy on art projects.

Artificial nature

One of Eliasson's art projects was *Green river* from 1998 to 2001, with which he put the inhabitants of Stockholm, Tokyo, and other global cities in turmoil by, with no prior announcement, coloring their rivers a toxic green with an environmentally friendly dye. In 2003–4, *The weather project* turned the Turbine Hall of the Tate Modern into a place for novel sensory experiences. It attracted millions of visitors to the Tate to try out for themselves the effects of an artificially glowing sun shrouded in mist. In 2008, the artist realized another project in public space, the widely seen *New York City Waterfalls*. For a period of 110 days, four artificial waterfalls were in operation in the East River between the Manhattan Bridge and Governor's Island.

In his works, Olafur Eliasson explores visual and physical phenomena. Kaleidoscopes conjure up specific color and lighting effects, colored lamps bathe the rooms and all the objects in them in yellow light, and stroboscopes illuminate a jet of water and seemingly "freeze" the drops in the air. Eliasson achieves stunning effects by simple means without needing to conceal the technical tricks involved. Basically, the works are about the relationship between the viewer and the object,

with the viewer's reactions being part of the work. They are experiments with the way we habitually see things, with the artist deliberately seeking to set up patterns and introduce a new element into them.

In 2009, Eliasson—by then a professor at the Berlin University of the Arts—set up the Institute for Spatial Experiments. He has won numerous art prizes, including the Danish Crown Prince Couple's Culture Prize in 2006 and the Joan Miró Prize in 2007. He lives and works in Copenhagen and Berlin. cw

1967 Born in Copenhagen, Denmark
1989–95 Studies at the Royal Danish Academy of Fine Arts, Copenhagen
1995 Founded the Olafur Eliasson Studio in Berlin
2003 Represents Denmark at the 50th Venice Biennale with his work *The blind pavilion*
SINCE 2006 Professor at Berlin University of the Arts
2007 Awarded the Joan Miró Prize
2010 Takes part in the 12th Venice Biennale of Architecture with his work *Your split second house*

Olafur Eliasson, 2010

above
Olafur Eliasson, *The blind pavilion*, 2003,
wood, steel, paint, glass (black and
transparent), 250 x 750 x 750 cm,
installation view: Pfaueninsel, as part
of the exhibition *Innen Stadt Außen*
(*Inner City Out*), Berlin, 2010, Courtesy
the artist, neugerriemschneider, Berlin,
Tanya Bonakdar Gallery, New York

right
Olafur Eliasson, *Green river*, Stockholm,
Sweden, 2000

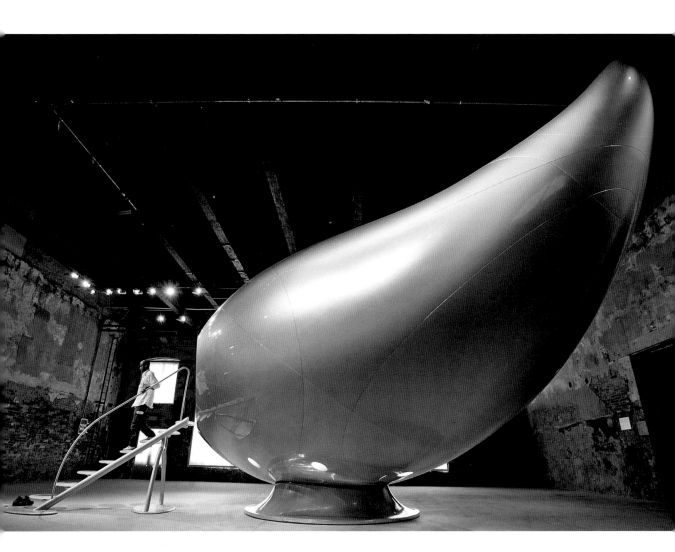

Mariko Mori, *Wave UFO*, installation
view, 51st Venice Biennale, 2005

1983 Production of the first
commercial mobile phone

1995 Japanese electronic pet
Tamagotchi launched

2009 Swine flu epidemic

2004 Disastrous
floods in Asia

2010 Researchers at the Westfälische Wilhelms
University discover signs of water on Mars

| 1975 | 1980 | 1985 | 1990 | 1995 | 2000 | 2005 | 2010 | 2015 | 2020 | 2025 |

MARIKO MORI

In the mid-nineties Japanese artist Mariko Mori received international acclaim for her innovative multimedia works.
Born in Tokyo and currently residing between her birthplace and New York, her work combines the contrast between
the old and new worlds, tradition and futurism.

Mariko Mori mixes elements of Japanese culture and religion with motifs from Eastern and Western art history, layering props from popular fashion, design, music, science fiction, and comics. She moves at the frontier between reality and Utopia, bearing witness to experiences of transformation and transcendence and creating a supernatural world of her own.

Self-portraits as cyber-beings

In her early photographs and video works, Mori herself was the principal protagonist, appearing in fantastical, bizarre outfits. She popped up as an alien, futuristic being in silver high-tech overalls in the busy streets of mega-city Tokyo, as a synthetic mermaid in the world's largest indoor waterpark, the Seagaia Ocean Dome in Japan, and floated from place to place in a transparent capsule like a time traveler. A team of employees supports her in realizing her perfectly staged and processed images, assisting with the designs, costumes, makeup, and hair; handling lighting, cameras, sound, and engineering; and with computer animation and design.

Timeless spaces

Her 3-D video *Nirvana*, presented at the 47th Venice Biennale in 1997, highlights the artist's growing interest in spirituality. The work shows Mariko Mori as a goddess in meditation on the road to enlightenment. The walk-in architectural work *Dream Temple* (1999), inspired by Japan's Yumedono Temple, also grew out of her close study of Japanese Buddhism.

Mori's *Wave UFO* project, created between 1999 and 2002, also leads to a world beyond the everyday. Car developers, IT specialists, architects, musicians, and doctors—in fact, a whole team of specialists—participated in the lavish project. But the spaceship model is also an interactive installation; upon entering the capsule, visitors are wired up and can watch the computer-generated drama of their own brain activity in real time, and how it combines with that of other visitors. The artist thus visualizes the way "human beings as collective living beings shall unify and transcend cultural differences and national borders through positive and creative evolution."

Mariko Mori studied at Bunka Fashion College in Tokyo, and also attended the Byam Shaw School of Art and Chelsea Art College in London. Since then, her works have been shown in numerous solo exhibitions all over the world, including at the Museum of Contemporary Art in Tokyo and the Centre Georges Pompidou in Paris. cw

1967 Born in Tokyo, Japan
1988 Graduates form Bunka Fashion
College, Tokyo; moves to London
1988–89 Studies at the Byam Shaw
School of Art, London
1989–92 Studies at Chelsea College
of Art, London
1992–93 Takes part in the Indepen-
dent Study Program of the
Whitney Museum of American Art
2005 Her work *Wave UFO* is shown at
the 51st Venice Biennale

Mariko Mori, 2005

1968 Assassination
of Martin
Luther King

| 1920 | 1925 | 1930 | 1935 | 1940 | 1945 | 1950 | 1955 | 1960 | 1965 | 1970 |

left
Sam Taylor-Wood, *Escape Artist
(Multicoloured)*, 2008, C-type print,
134.6 x 109.2 cm, Courtesy White Cube,
London

right
Sam Taylor-Wood, *Bram Stoker's Chair
II*, 2005, C-print, 121.9 x 96.5 cm,
Courtesy White Cube, London

1974 Muhammad Ali regains world
heavyweight boxing title

1987 Black Monday (October 19) sees
stock markets crash worldwide

1997 Kyoto Protocol on climate

2009 General Motors declares bankruptcy
2007 Al Gore awarded Nobel Peace Prize
2010 Disastrous oil leak in
the Mexican Gulf

1975 1980 1985 1990 1995 2000 2005 2010 2015 2020 2025

SAM TAYLOR-WOOD

Sam Taylor-Wood likes to bend the rules of time and space. Her photographs and films show dancers defying gravity, animals decaying at rapid speed, and people singing without making a sound. These creations redefine the role of the image in a media-driven age.

The art of the performer pervades Sam Taylor-Wood's work. As a child, Sam's recently divorced mother moved her family into a hippie commune. But Sam rebelled against the notion of escaping from the wider world. She would develop a style of art that confronted popular culture directly.

From her early days as an artist, Taylor-Wood has used her own self-portrait to explore larger issues of body image and stereotyped female roles. In *Slut* (1993), the artist's face and neck are highlighted against a dark background, revealing the evidence of a woman who has been with a lover. The viewer sees her carefully made-up eyes and lips, as well as the reddened "love bites" on her neck. But the face also seems self-conscious; her eyes are closed and the expression on her mouth is one of embarrassment. These contradictory visual elements expose the complex "expectations" of women in society.

Taylor-Wood has also explored other forms of performance. Her first successful films tested the possibilities of multi-screen presentations. *Travesty of a Mockery* (1995) depicts a couple having an argument, with the man and the woman each "acting out" on their own screen. Taylor-Wood physically separates the two characters to emphasize the emotional barriers that stand between them. *Atlantic* (1997) expands on these ideas by using three screens to depict an argument in a restaurant: one screen focusing on the woman's face, a second focusing on the man's hands, and a third showing the entire scene. In discussing this work, Taylor-Wood has said that she wanted the viewer to "project what the discussion or argument is about. The viewer is put in the position of the people in the restaurant who are onlookers.... I want people to construct their own narrative, so they're looking at it and giving it endless possibilities."

Many of Taylor-Wood's best-known creations introduce theatrical fantasy. The self-portraits *Escape Artist (Multicolored)* (2008), *Bram Stoker's Chair II* (2001) and *Self-Portrait Suspended V* (2004)

use photographic trickery to show the artist suspended in mid-air. Some of these works feature Taylor-Wood engaged in elaborate aerial gymnastics, while others show her body slumped over and "helped up" by balloons. Such imagery speaks to the artificial, manipulative nature of the media. Other works use fantasy to explore fears of aging and death. The films *Still Life* (2001) and *A Little Death* (2002) show fruits and rabbits decomposing with unnatural rapidity.

Taylor-Wood has long had close connections to the world of professional performers. She has photographed many celebrities, including actors Benicio Del Toro and Hayden Christensen. One of her most offbeat portraits captures star athlete David Beckham asleep, a nod to the Pop Art films of Andy Warhol. Taylor-Wood has also used movie stars in short films that draw parallels between iconic symbols and modern celebrity. One of the best-known examples is *Pietà* (2001), which features Taylor-Wood holding up a Christ-like Robert Downey, Jr. In 2009, the artist released her first feature-length film, *Nowhere Boy*, a movie that reflects her continuing interest in the role of women in pop culture. *Nowhere Boy* focuses on the ways that John Lennon's mother and aunt influenced him during his pre-Beatles years. *bf*

1967 Born in Croydon, England
1990 Graduates from Goldsmiths' College, London
1997 Nominated for the Turner Prize; awarded the Illy Café Prize for Most Promising Young Artist at the 47th Venice Biennale
2004 Her series *Crying Men* portrays crying Hollywood stars such as Sean Penn and Paul Newman
2009 Her film *Nowhere Boy* on John Lennon's youth is shown at the London Film Festival
2015 Directs *Fifty Shades of Grey*, the film adaption of the best-selling erotic novel

Sam Taylor-Wood, 2010

TAL R ▬▬▬▬▬
CHRIS OFILI ▬▬▬▬▬
JONATHAN MEESE ▬▬▬▬▬

1969 Jonathan
Beckwith
isolates the
first gene

1920　　1925　　1930　　1935　　1940　　1945　　1950　　1955　　1960　　1965　　1970

1979 Saddam Hussein comes to power

1996 British scientists postulate
a link between BSE and
Creutzfeldt-Jakob disease

1991 War in the Balkans breaks out

2009 Cologne city archive collapses

2006 Two Munch pictures stolen in August 2004—
The Scream and *Madonna*—are returned

2010 Mass panic at the Love Parade in Duisburg

2003 Actress Katharine Hepburn dies

| 1975 | 1980 | 1985 | 1990 | 1995 | 2000 | 2005 | 2010 | 2015 | 2020 | 2025 |

TAL R

Tal R mixes and matches the artistic styles of the past. Kaleidoscopic patterns from the seventies, Picassoesque collages, and reminders of German Expressionism all make their way into his vibrant paintings. Tal's joyfully eclectic work extols the virtues of saving and reinterpreting discarded parts of our culture.

Tal R thinks of himself as a soup man. In a recent interview he said, "I constantly have this hotpot boiling and I throw all kinds of material into it; you know, personal experiences and things that interest me, for example, a record sleeve or the title of an album. I look for different patterns of working, and am constantly trying out new mixes and ways of combining things." The hotpot of Tal R's imagination has enabled his art to explore a rich array of themes and images.

Tal was born in Israel and grew up in the seventies, a period that left its mark on his psyche. After studying art in Copenhagen, he moved permanently to Denmark, where his work began acquiring international acclaim. Many critics have seen Tal R's oil paintings as a throwback to the traditions of early-twentieth-century art: bold colors, thick brushwork, and storybook characters and landscapes.

Some of Tal's early works, however, seem directly inspired by hippie culture. In *Moon Star and Planets* (1999), the interlocking feet of a couple are shown under a canopy of psychedelic stars and planets. This humorous scene pokes fun at the age of "free love." *Lords of Kolbojnik* (2002–3), a work reminiscent of a seventies album cover, uses collage techniques to produce an explosion of color: a giant starburst is surrounded by an army of pasted clippings from magazines and other sources. The clippings show people and things from the past; figures that represent everything from religion to sex. Tal has rescued such "throwaway" figures from the *kolbojnik*—a Yiddish word for garbage can—and given them new life and meaning. Similar concepts appear in *Sisters of the Kolbojnik* (2002). Here Tal paints a group of long-haired women in bell-bottom pants, showing them united and defiantly asserting their presence under a giant mushroom!

Other Tal R works incorporate discarded images from more remote times and places. *New Quarter* (2003) depicts a Mexican town with shady bandits and other characters drawn from old Western films.

Yet like the women of the *kolbojnik*, these men are presented as a proud, close-knit group. In *The Japan* (2009), a postcard-shaped scene of antique Japanese life is set against boldly colored horizontal lines. Such lines seem to resemble the waves of an ocean, an ocean that divides traditional notions of society from present-day realities. *We are the Elephants* (2010) shows an abstract 1920s nightclub reminiscent of the Cubist works of Pablo Picasso. It features half-human, half-guitar figures that represent the "white elephants" of art.

Tal has also experimented with other artistic media. In his bronze sculpture *Onions* (2005), he arranges a group of onion-like forms on sticks to create an abstract family portrait. Tal's black-and-white prints reveal an expressive sense of line, and they also present multiple characters that relate to one another in various ways. As with much of Tal R's imagery, these characters seem to express the artist's desire for creating and re-creating viable communities. *bf*

1967 Born in Tel Aviv, Israel as
Tal Rosenzweig
1986–88 Studies at Billedskolen,
Copenhagen
1991–93 Teaches at Nut Cracker-Art
School, Copenhagen
1994–2000 Studies at the Royal
Danish Academy of Fine Arts,
Copenhagen
SINCE 2004 Teaches painting at the
Düsseldorf Art Academy
2005 *Mor*, Statens Museum for
Kunst, with Jonathan Meese,
Copenhagen
2010 Exhibition *Tal R*, Contemporary
Fine Arts, Berlin

left page
Tal R, *Lords of Kolbojnik*, 2002, mixed
media on canvas, 244 x 244 cm, Courtesy
Contemporary Fine Arts, Berlin

above
Tal R, undated

Tal R, *Onions*, 2005,
bronze, 107 x 50 x 40 cm,
Courtesy Contemporary
Fine Arts, Berlin

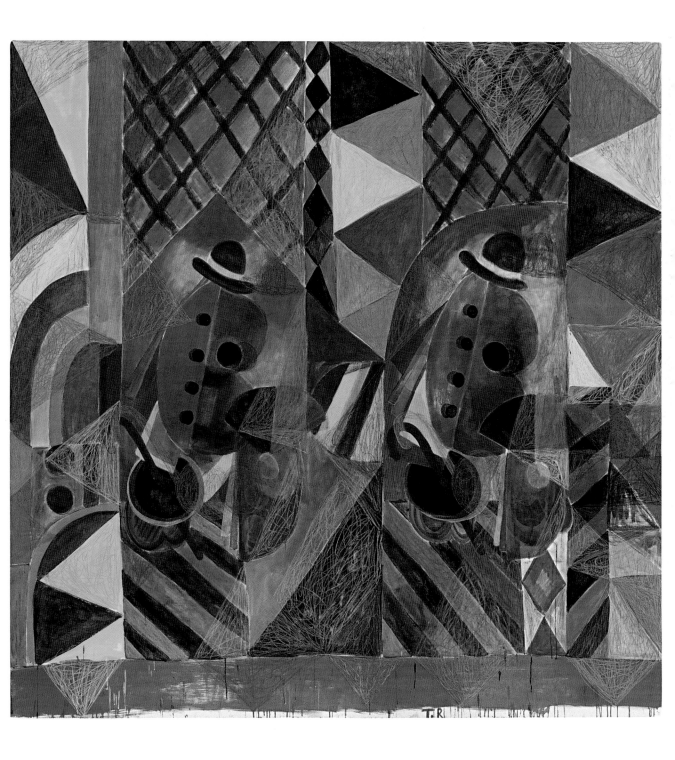

Tal R, *We are the Elephants*, 2010, animal glue, pigment and wax crayon on canvas, 250 x 250 x 4.5 cm, Courtesy Contemporary Fine Arts, Berlin

1969 Woodstock Festival in upstate New York

1920 1925 1930 1935 1940 1945 1950 1955 1960 1965 1970

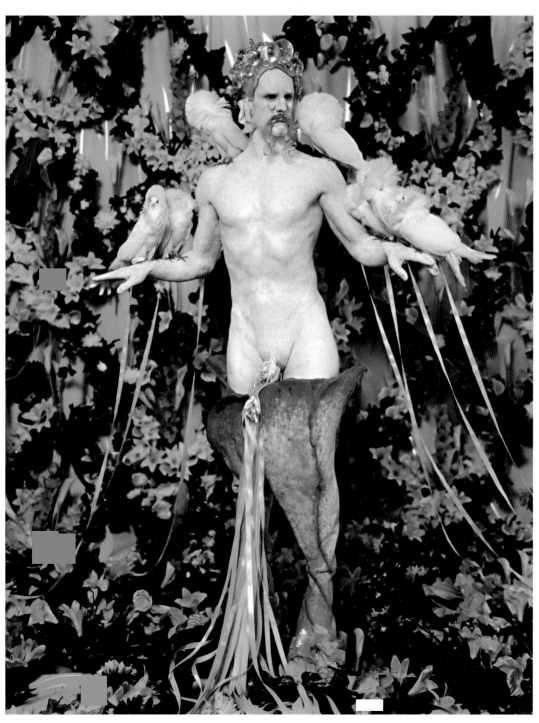

Matthew Barney,
Cremaster 5, 1997,
production still,
Courtesy Gladstone
Gallery, New York

Matthew Barney sees himself as a sculptor, but expands the concept of sculpture to encompass film, video, performance, drawing, photography, and installation. Known for his fantastic and often surreal concepts, he inexorably rose to the top of the art world due largely to his lavish, multipart film and performance series Cremaster *and* Drawing Restraint.

According to the jury awarding the Goslar Kaiserring in 2007, the American artist is "one of the great symbolists of the last fifty years, who as a utopian has created artistic works dealing with the theme of the boundaries of the sexes.... An unforgettable labyrinthine private cosmos has come into being in which possible human creative processes, with motives and symbols from mythology, history, geology and architecture, are melted into a mysterious parallel universe."

Beautifully bizarre

Barney's "private cosmos" includes the five-part, non-chronological film project *Cremaster* (1994–2002)—supplemented by photographs, drawings, installations, performances, and sculptures—that the artist sees as a meditation on the creative process. A biological model served as a source of inspiration: the first weeks of embryonic development during which occurs the process of sexual differentiation. The title of the work refers specifically to the male cremaster muscle, which controls the temperature of the testicles and thus influences the future sex of the fetus. The Cremaster cycle combines extraordinary complex plot lines with a variety of bizarre symbols that reference sexual reproduction, and, as the film cycle progresses, an increasing emphasis on biographical, historical, and cultural motifs. Barney both wrote and directed the cycle, creating a true art film of splendid images, operatic stage props, and mythical figures. In each part, he assumes the leading role; others who have appeared include actress Ursula Andress, artist Richard Serra, and the writer Norman Mailer.

Another elaborate project is the now eighteen-part *Drawing Restraint* series begun in 1988. The underlying concept is that a form can only take shape by struggling against obstacles. Barney designed environments with various impediments that would hamper his work. The drawing process is thus transformed into ingenious "actions" captured for the camera: creating a self-portrait on the ceiling while bouncing on a trampoline, working as elastic bands restrain his freedom of movement, or performing acrobatic glissades while wearing ice skates. As time passes, his exercises grow increasingly taxing. The athletic theme becomes a model of artistic creativity—during his student days, Barney played American football. In the sequel, he transfers this principle to a narrative: the art film *Drawing Restraint 9* tells the story of oil extraction and the tradition of whaling, while below deck a tragic love story unfolds with the artist and his wife, Icelandic singer and actress Björk, in the principal roles. Barney elevates the story to a mythical/allegorical plane as the film ends with the transformation of the lovers into whales and their escape into the sea. *cw*

1967 Born in San Francisco, California
1973 Moves with his family to Boise, Idaho
1985 Enrolls as a pre-med student at Yale University
1987 Begins his *Drawing Restraint* series
1989 Graduates from Yale with a degree in the arts; moves to New York City
1991 Features as the cover story of the summer issue of *Artforum*; has a solo debut at the Gladstone Gallery in New York
1993 Wins the Deumila Prize at the 45th Venice Biennale
1994 Begins work on *The Cremaster Cycle*, a five-part film project
2002 Completes *The Cremaster Cycle*
2005 Exhibits his *Drawing Restraint* series at the 21st Century Museum of Contemporary Art in Kanazawa, Japan; releases the film *Drawing Restraint 9*
2010 Stages *KHU*, the 2nd part of his new performance series Ancient Evenings in Detroit

above
Matthew Barney, 2007

following double page
Matthew Barney, *Cetacea*, 2005, cast polycaprolactone thermoplastic, self-lubricating plastic and vivac, 87 x 1219 cm, installation view: Kunsthaus Bregenz, Courtesy Gladstone Gallery, New York

left
Matthew Barney, *Drawing Restraint 5*, 1989, production still, Courtesy Gladstone Gallery, New York

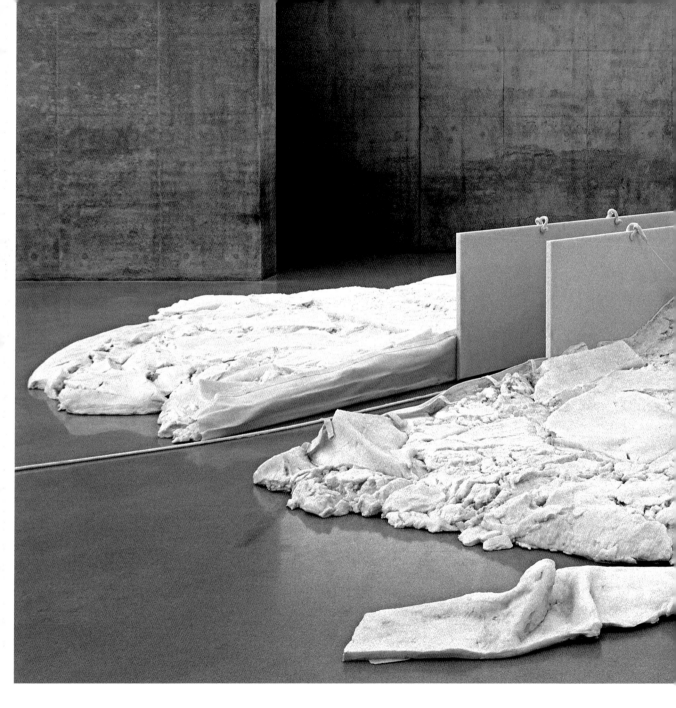

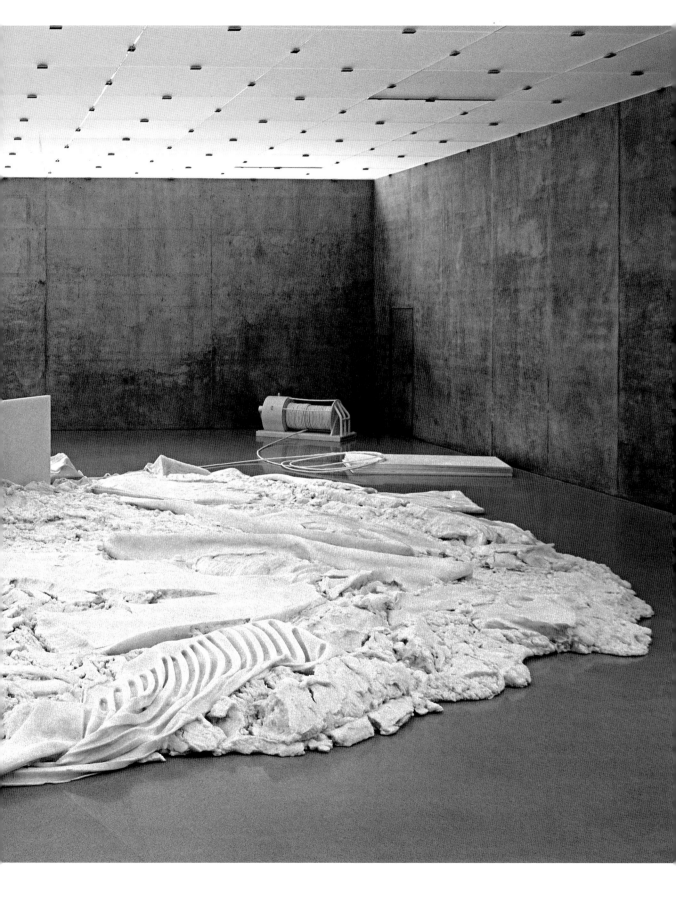

1920 1925 1930 1935 1940 1945 1950 1955 1960 1965 1970

Wolfgang Tillmans,
Freischwimmer 78, 2004,
C-Print, 239 x 181 cm,
Courtesy the artist and Andrea
Rosen Gallery, New York

1970 Willy Brandt genuflects at the monument to
the victims of the Warsaw Ghetto uprising

1977 German Autumn
(Baader-Meinhof gang)

1986 Chernobyl disaster

1993 Bill Clinton sworn in as
the 42nd US president

1996 France's final atomic bomb
test on Mururoa Atoll

2002 Euro introduced

2007 Death of German painter Jörg Immendorff

2009 Air France Flight 447 crashes into the
Atlantic Ocean, killing 228 people

1975 1980 1985 1990 1995 2000 2005 2010 2015 2020 2025

WOLFGANG TILLMANS

In the late eighties, Wolfgang Tillmans developed a unique photographic style of international repercussion that proved widely influential on both fashion and lifestyle photography. Tillmans earned prestigious awards, including the London Tate Gallery's 2000 Turner Prize, the first photographer and first German artist to receive the award.

Wolfgang Tillmans, born in Remscheid, Germany in 1968, initially gained attention through his snapshots of the young subculture in London clubs and events such as the Love Parade in Berlin. With his portraits of the young, he rightly earned a reputation as the chronicler of his own generation. And yet he was a careful observer of his environment, taking pictures of everyday urban life, landscapes, nature, or still lifes. Though at first glance his series on folds or solar eclipses seem like snapshots, they are in fact the result of a meticulous, time-consuming process.

Magic paper

Tillmans' oeuvre evinces a frankness and amazing breadth that he has expanded by focusing on the very process of photography itself. His abstract pictures are products of the laboratory produced without a camera and solely with the effects of light. Streaks of color and fine patterns feature in series such as *Blushes* (2000) or *Freischwimmer* (2003–5). The focus is placed on materiality rather than representation when, for example, Tillmans carefully folds or artfully crumples photo prints after exposure. In his *Lighter* series (2006–8), pictures become objects. Since 2006, Tillmans has also been experimenting with analog photocopies and the dissolution of the image through significant magnification.

 Another striking aspect of the artist's oeuvre is his innovative exhibition concepts and forms of presentation. He frequently hangs his paper prints directly onto the wall with tape, and mixes large and small formats. This combinative principle is also used to mix his photos with text and images from print media and the Internet in display cases or complex tabletop and wall installations. In so doing, he avoids assigning fixed meanings, and raises questions in different contexts about the truthfulness of images and messages, and ultimately permits a continual re-evaluation of his own work.

Wolfgang Tillmans published his first photographs in popular magazines such as *Spex* or *iD*, and exhibited in galleries before being given solo shows at leading international museums and publishing numerous artist books and catalogues. Following a visiting professorship at the College of Fine Arts in Hamburg, he has taught since 2003 at the Städel in Frankfurt. Tillmans remains "fascinated by how an industrially produced piece of paper becomes an object of great beauty and meaning with the mere addition of light." He lives in Berlin and London. In London, his Between Bridges Gallery serves as a platform for underexposed and often politically engaged artists. *cw*

1968 Born in Remscheid, Germany
1987–90 Lives in Hamburg
1990–92 Attends Bournemouth and Poole College of Art and Design, England
1992–94 Lives in London
1994–95 Lives in New York City
1996 Settles in London
1998–99 Guest professor at the College of Fine Arts, Hamburg
2001 *Aufsicht (Supervision)*, exhibition at Deichtorhallen, Hamburg
2000 Awarded the Turner Prize
2003 *If One Thing Matters, Everything Matters*, Tate Britain, London
2003–6 Professor of Interdisciplinary Art, Städelschule, Frankfurt am Main
2004 *Freischwimmer*, Tokyo Opera City Art Gallery
2005 *Truth Study Center*, Maureen Paley, London
2006 *Freedom from the Known*, P.S. 1 Contemporary Art Center, Long Island City, New York

Wolfgang Tillmans, undated

1970 British
rock band
Queen
forms

1920 1925 1930 1935 1940 1945 1950 1955 1960 1965 1970

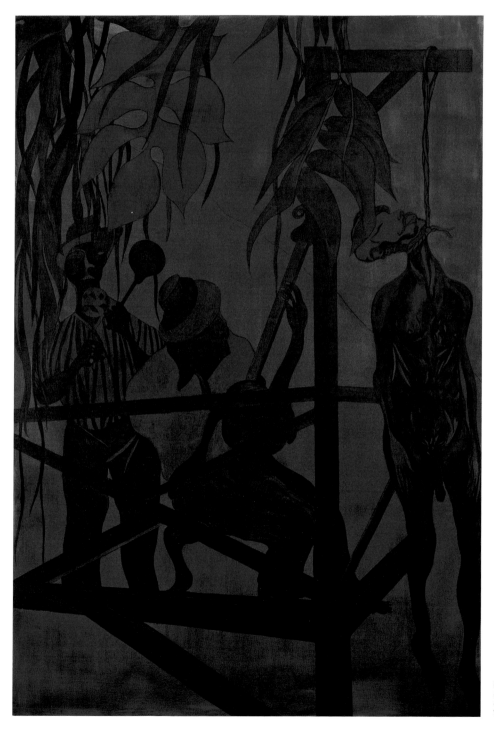

Chris Ofili, *Iscariot Blues*, 2006, oil and
charcoal on linen, 281 cm x 194.9 cm,
courtesy David Zwirner, New York and
Victoria Miro Gallery, London

1976 First G7 summit

1988 *Freeze* exhibition in London launches Young British Artists

2005 Founding of YouTube

2000 Dot-com bubble bursts

1992–1995 Bosnian War

2010 Largest art heist in history at the Museum of Modern Art in Paris

1975　1980　1985　1990　1995　2000　2005　2010　2015　2020　2025

CHRIS OFILI

Ofili's works bridge the sacred and the profane, popular culture and beliefs. They combine fluid, often simple forms with intriguingly rich detail.

Chris Ofili came to prominence in the early nineties with richly orchestrated paintings combining rippling dots of paint, drifts of glitter, collaged images, and elephant dung—varnished, often studded with map pins and applied to the picture surface as well as supporting the canvas—a combination of physical elevation and symbolic link to the earth.

Ofili's early works draw on a wide range of influences, from African artistic practices to blaxploitation films, fusing comic book heroes and icons of funk and hip-hop, along with Western art-historical traditions. In one of his most striking early works, *No Woman, No Cry* (1998), he created a poignant memorial to Stephen Lawrence, the murdered son of British human rights activist Doreen Lawrence. The work focused on the grief of the mother, rendering a woman in profile with crystalline tears flowing down her face, a face partly obscured by a veil-like, beaded pattern. Ofili used a complex array of materials to give his subject both a passionate humility and a shimmering elegance.

Early paintings focused on less explicitly political themes. *The Adoration of Captain Shit and the Legend of the Black Stars* (1998) employed urban pop culture imagery. The work's central figure—complete with unbuttoned shirt and chest hair—echoed the heroes of 1970s action films and comic books. Painted stars, each with a pair of gazing eyes, surrounding the Captain and visible through his transparent body, suggest the impermanent nature of cultural myths. The success of such works helped Ofili win the prestigious Turner Prize in 1998 for best young British artist.

Ofili's style has evolved in the new millennium, especially after his move from London to Trinidad in 2005. His paintings have begun to show a bolder and often more simplified color palette. Some of these more recent works, including *Iscariot Blues* (2006) and *Lover's rock-guilt* (2007), experiment with deep blue shades. They seem to suggest the heavy, tropical atmosphere of Ofili's Caribbean home, with the former work a striking sensual depiction of the last moments of the biblical Judas set against the Trinidadian landscape. Other images, like *Dance in the Shadow* (2009) and *Douen's Dance* (2007), possess a vibrant, musical quality that hearkens back to the Jazz Age and 1920s Expressionism.

Ofili has also produced works in other media. His delicate pencil drawings featuring tower-like forms made up of tiny Afroed heads incorporate a richness of detail and power of suggestion that exist in all of Ofili's artwork. Meanwhile, sculpture has become an increasingly important element, allowing for further experimentation with form and subject matter. The bronze figure *Mary Magdalene (Infinity)* (2006) displays the artist's characteristically fluid forms. Mary's limbs suggestively twist and cross to produce a feeling of subtle, continuous movement, reflecting both her sensuality and her timeless spiritual appeal.

Alongside recent developments in the artist's material choices, Ofili has remained faithful to a pictorial style that relies on a conscious flattening of the picture plane, carefully layered surfaces, and diverse sources of inspiration.

1968 Born in Manchester, England
1988–91 Studies at Chelsea School of Art, London
1991–93 Studies at Royal College of Art, London
1997 Takes part in the exhibition *Sensation* of Young British Artists
1998 Solo Exhibition at Serpentine Gallery, London; awarded the Turner Prize
2003 Represents Britain at the 50th Venice Biennale
2005 Solo exhibition at The Studio Museum in Harlem, New York
2006 Solo exhibition at Kestner-gesellschaft, Hanover
2010 *Chris Ofili*, Tate Britain, London; Solo exhibition at The Arts Club of Chicago

1920 1925 1930 1935 1940 1945 1950 1955 1960 1965 1970

Doug Aitken, *Frontier*, 2009, installation
view, Tiber Island, Rome, Courtesy of
303 Gallery, New York

1990 34 CSCE states declare
the Cold War over

2005 Hurricane Katrina devastates New Orleans

1981 Ronald Reagan sworn in
as 40th US president

2002 US opens detention camp in Guantánamo

970 Robert Smithson creates
Spiral Jetty in Great Salt
Lake, Utah

1996 British scientists postulate a link between
BSE and Creutzfeldt-Jakob disease

2010 Earthquake in Haiti kills 220,000

1975 1980 1985 1990 1995 2000 2005 2010 2015 2020 2025

DOUG AITKEN

Doug Aitken's art carves out its own space, incorporating and redefining iconic buildings, urban spaces, and rural landscapes. His multi-screen video installations surround viewers with sound and image, creating a complex web of stories and ideas.

The sensual exhibits of Doug Aitken reveal an interest in "how people occupy space and how they negotiate what they do and why." His installations are about individual lives, but also about the role of individuals in collective society and the natural world. In early works such as *Interiors* (2002), Aitken displayed the characteristic format that he would use to explore these themes—multiple screens, interrelated stories, and cunningly chosen sound that immersed his viewers in the "performance." This style of art gradually led Aitken to create progressively larger and more complex works.

In one of Aitken's first monumental outdoor exhibits, *Sleepwalkers* (2007), he covered the walls of New York's Museum of Modern Art with huge video projections. These videos depicted the activities of five celebrity performers, including the actors Donald Sutherland and Tilda Swinton and the musician Cat Power. Aitken's nocturnal images drew viewers in from the street and enveloped them within the museum's courtyard. The videos were structured to highlight the interconnectedness of their characters' lives. Performers were often shown engaged in sleeping, bathing, and other activities at the same time. The production also featured drum music that complimented the rhythm of the characters' actions. Aitken wanted his piece to "capture the multiple facets of a living city as if seen through a cut diamond, revealing a kaleidoscope of simultaneous views."

In a more overtly provocative exhibit called *Migration* (2008), Aitken merged the urban and natural worlds. Multiple widescreen videos featured wild North American animals trapped in mundane hotel spaces. In one arresting scene, a buffalo was shown rustling bedcovers and knocking over furniture in a motel bedroom. These familiar human places became oddly exotic through the animals' unpredictable actions. The images made viewers consider how people use the spaces they build, while commenting on the repetitive, impersonal nature of twenty-first-century human lives.

Sonic Pavilion (2009) also explored the relationships between nature and human interests. The exhibit was designed for an "art park" called Inhotim in rural southeastern Brazil. From the top of a small hill, Aitken's team dug a hole about one mile deep, then installed microphones and other sound equipment at the bottom so that the subtle movements of the earth could be detected as distinct sounds at the top. Aitken's group also built a circular, glass-filled pavilion surrounding the hole: a structure with acoustics that could further enhance the noises underground that ranged from long grumbling notes to nearly inaudible whispers. The constantly changing nature of these sounds enabled Aitken to create a "living artwork ... that will never be the same twice."

Aitken carved out another space for his art in *Frontier* (2009). The installation's modernist pavilion stood in the heart of ancient Rome, on an island in the Tiber River. On the walls of the pavilion's interior, Aitken projected videos of the artist Ed Ruscha walking through a variety of landscapes. Like most of Aitken's work, the exhibit engaged the viewer in multiple ways—through sound, images, and space. It also addressed a complex array of themes, contrasting the restless nature of individual human lives with the more slowly evolving river and ancient city. *bf*

1968 Born in Redondo Beach, California
1987–91 Studies at the Art Center
College of Design, Pasadena,
California
1986–87 Studies at Marymount
College, Palos Verdes, California
1999 Awarded the International Prize
at the 48th Venice Biennale for
his installation *Electric Earth*
2000 Takes part in the Whitney
Biennial, New York
2007 His installation *Sleepwalkers* is
shown at the Museum of Modern
Art, New York
2007 First Prize, German Film Critics'
Award, KunstFilmBiennale,
Cologne
2008 Takes part in the 55th Carnegie
International: *Life on Mars*,
Pittsburgh
2009 Opening of his *Sonic Pavilion*
at Inhotim, Brazil

left
Doug Aitken, *Migration*, 2008,
installation view at the 55th Carnegie
International: *Life on Mars*, Carnegie
Museum of Art, Pittsburgh, Courtesy
of 303 Gallery, New York

above
Doug Aitken, 2009

Doug Aitken, *Migration*, 2008, film still,
Courtesy of 303 Gallery, New York

Gregor Schneider, *LIEBESLAUBE*, Rheydt 1995,
room within a room, construction made of
blockboard and wood, 1 window, 1 lamp, 1 tub,
1 radiator, 1 cupboard, gray wooden floor, white
plastered walls and ceiling, 416 x 285 x 315 cm,
Haus u r, Rheydt, Germany, 1995–96

1977 First *Sculpture Project* in Münster

1997 UN climate conference ends
with the Kyoto Protocol

2009 Winnenden, Germany school massacre

1971 Women's suffrage introduced
in Switzerland

1987–93 First Palestinian
intifada

2001 iPod launched

2010 Volcanic ash from Iceland causes
havoc on European air space

| 1975 | 1980 | 1985 | 1990 | 1995 | 2000 | 2005 | 2010 | 2015 | 2020 | 2025 |

GREGOR SCHNEIDER

Displacing, duplicating, and reconstructing architectural structures is for Gregor Schneider an artistic principle.
For years his work has focused on the private home as a place of withdrawal from the world, but of late his attention has
turned primarily to spaces relevant to society but not open to the public, such as religious centers or high-security areas.

Schneider's best-known work is the ongoing altera-
tion and remodeling of his parents' house in Rheydt
in the Lower Rhineland, begun in 1985. Convoluted
and isolated rooms, corridors reduced to claustro-
phobic dimensions, windows without a view,
machine-generated wind: Schneider created a world
of his own that to most visitors seems rather
simple—oppressive and eerie. It is not so much the
architectural interventions themselves that interest
the artist, but rather the effects of his walk-in
sculptures; if, for example, a ceiling moves several
inches up and down in slow motion or a front door
no longer leads out.

Schneider and his shell
The title *Haus u r* refers to the house's address: "u"
represents the street (i.e. Unterheydener Strasse,
12); "r" is short for Rheydt. Eventually, Schneider
began to dismantle parts of the building in order to
show them at gallery shows, international exhibi-
tions, and museums. In 2001, he was invited to
transplant his house to Venice. More than twenty
rooms were reconstructed in the German Pavilion of
the Biennale, and Gregor Schneider won the Golden
Lion for his *Totes Haus u r* (Dead House u r).

It was again rooms, though this time not private
ones, that interested the artist in *Cube* (2007), con-
structed outside the Kunsthalle in Hamburg. The
forty-six-foot black cube is based on the Kaaba in
the Great Mosque in Mecca, which attracts five
million devout pilgrims a year. Schneider's proposals
to re-erect the work in St. Mark's Square in Venice
and in front of Hamburg's main station were both
rejected after fierce political debate.

In 2008, Schneider set off another firestorm by
announcing that he would like to present someone
dying a natural death, or recently deceased, in a
portable room he constructed, so as to show the
"beauty of death." The idea provoked violent reac-
tions. He was accused of abusing artistic freedom
for the purposes of provocation and of depriving

death of its dignity. The artist bluntly dismissed
these accusations: "Perhaps we shall manage to
liberate death from its taboo, to make it a positive
experience, like the birth of a child."

The media fuss about Schneider's "death room"
diverted public attention from his actual work. Still
living in his native Rheydt, he continues to work on
constructed rooms. After various visiting professor-
ships, in Los Angeles, Copenhagen, and elsewhere,
since 2009 he has had a professorship at the Berlin
University of the Arts. cw

1969 Born in Rheydt, Germany
1985 First solo exhibition *Pubertäre
Verstimmung* in Galerie Kontrast,
Mönchengladbach
1989–92 Studies at Düsseldorf Art
Academy, Academy of Fine Arts
Münster, and the College of Fine
Arts, Hamburg
1999–2003 Guest professor in
Amsterdam, Los Angeles,
Hamburg, and Copenhagen
2001 Awarded the Golden Lion at the
49th Venice Biennale for the
German Pavilion *Totes Haus u r*
2003 *Tote Haus u r* is shown at the
Museum of Contemporary Art
Los Angeles (MOCA)
2009 Professor at Berlin University of
the Arts

Gregor Schneider, undated

1969 Woodstock
Festival in
upstate
New York

1920 1925 1930 1935 1940 1945 1950 1955 1960 1965 1970

Kara Walker, *Bureau of Refugees: Mulatto hung
by a grapevine near road side between Tuscaloosa
& Greensboro*, 2007, cut paper on paper,
Courtesy of Sikkema Jenkins & Co., New York

1974 Muhammad Ali regains world heavyweight boxing title

1983 Civil war breaks out in Sudan

1992 *Projects 34: Felix Gonzalez-Torres* exhibition: billboards in 24 locations throughout NYC

1998 The Lewinsky affair makes the headlines

2003 US invasion of Iraq

2007–9 Global financial crisis

2010 Catastrophic floods in Pakistan

1975　1980　1985　1990　1995　2000　2005　2010　2015　2020　2025

KARA WALKER

The shadows of the past come to life in Kara Walker's imagery. Her black and white silhouettes confront painful realities of African-American history, using black and white stereotypes from the era of slavery to suggest persistent modern-day concerns.

The silhouette has a genteel tradition in American art. Beginning in the eighteenth century, it was a favorite medium for family portraits and book illustrations. Kara Walker is a student of that tradition. Her silhouettes reproduce the fancy ladies and gentlemen of America's antebellum South. But she uses these characters to create a nightmarish world—a world that reveals the brutality of American racism and inequality.

Walker began experimenting with the silhouette in college, finding it an effective way to "simplify complex themes." She created silhouettes of great size, and she used them to produce large-scale installations. Walker's graceful figures—cut from simple black paper—were inspired from her interest in Victorian literature and her knowledge of nineteenth-century African-American imagery. Her breakthrough exhibit, *Slavery! Slavery!* (1997), featured the stock characters from romantic tales of plantation life in the American South. They included hoop-skirted southern belles, elegant gentlemen in frock coats, and "adorable" slave children. But Walker's art poked holes in the romantic fiction of the past—exposing the desperate, humiliating realities of life for plantation slaves. Her white beau and belle were shown abusing the black children, while a hired white slave master was depicted raping a chained female slave. Walker also incorporated ominous, jagged details of the southern American landscape—fragments of Spanish moss trees and a giant moon obscured by dramatic, nocturnal clouds. All of these images surrounded the viewer in a claustrophobic, circular space. This format paid homage to another popular nineteenth-century tradition: the 360-degree historical painting known as the cyclorama.

Walker has said that her silhouettes reflect the way Americans continue to look at racism with a "soft focus"—avoiding "the confluence of disgust and desire and voluptuousness that are all wrapped up in ... racism." It is up to the viewer to see the

full-blooded human suffering that is only suggested in Walker's two-dimensional art.

Over the years, Walker has tested various methods of enhancing and sharpening her distinctive imagery. In her 2000 piece *Insurrection! (Our Tools Were Rudimentary, Yet We Pressed On)*, she placed her silhouetted plantation characters against a background of colored light projections. The exhibit's soft blue grass and deep pink sky gave it an especially transparent quality—reminiscent of production cels from animated films of the thirties. *Insurrection!* also hearkened back to the most famous of all plantation stories, *Gone With the Wind*, and the iconic Technicolor film based on that story. In addition, Walker's light projectors were set up to cast the shadows of viewers onto the exhibit's walls, making them appear to be "characters" in the play and encouraging them to confront the work's difficult themes. In the 2005 exhibit *8 Possible Beginnings or: The Creation of African-America, a Moving Picture*, Walker introduced moving images and sound, immersing the viewer even further into her dark worlds. Here the artist used her silhouettes as shadow puppets to explore the early history of American slavery. She also used her voice—and the voice of her daughter—to suggest how that heritage has affected her own image as an artist and an African-American woman. *bf*

1969 Born in Stockton, California
1982 Moves with her family to Stone Mountain, Georgia
1991 Receives BA from the Atlanta College of Art
1994 Receives MFA in painting and print making from the Rhode Island School of Design; exhibits her first silhouettes at the Drawing Center in New York
1997 Becomes the youngest-ever recipient of the MacArthur Foundation "genius" grant
2001 Joins the faculty of the Columbia University School of the Arts in New York
2002 Represents the United States at the São Paulo Bienal
2006 Curates the exhibition *After the Deluge* at the Metropolitan Museum of Art, New York
2007 Designs the cover for the August 23 issue of the *New York City* to commemorate the second anniversary of Hurricane Katrina

Kara Walker, undated

above
Kara Walker, *Untitled*, 2009, cut paper
and collage on paper, Courtesy of
Sikkema Jenkins & Co., New York

right
Kara Walker, *Darkytown Rebellion*, 2001,
cut paper & projection on wall, installa-
tion view: *Kara Walker: My Complement,
My Enemy, My Oppressor, My Love*,
Walker Art Center, Minneapolis, 2007,
Courtesy of Sikkema Jenkins & Co.,
New York

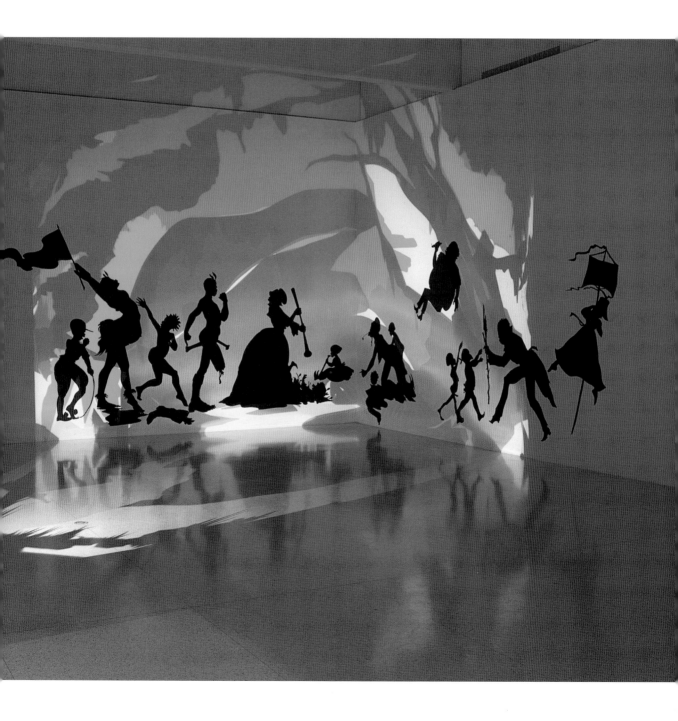

1920 1925 1930 1935 1940 1945 1950 1955 1960 1965 1970

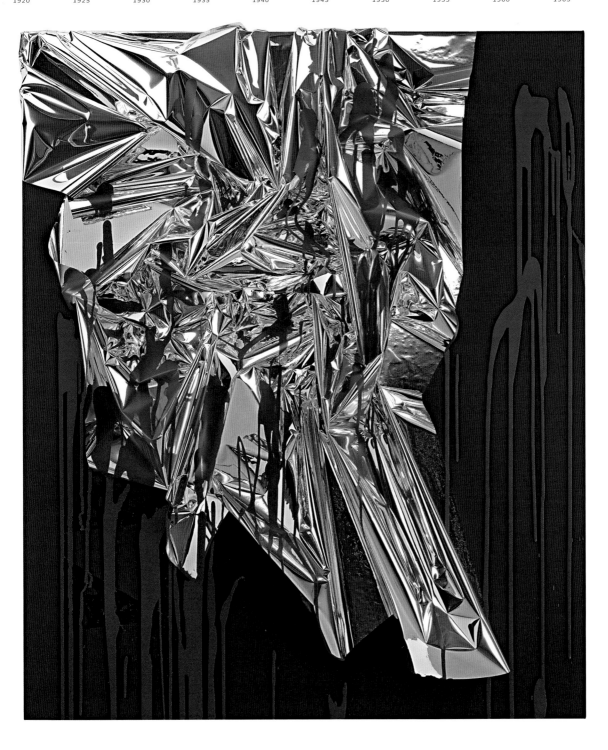

1973 First commercial
personal computer

1979 Second oil crisis

1990 German reunification

1995 Founding of eBay

2009 Cologne city archive collapses

2006 Death of former German president Johannes Rau

2010 Polish president Lech Kaczyński and many other
high-ranking Polish officials killed in plane crash

1975 1980 1985 1990 1995 2000 2005 2010 2015 2020 2025

ANSELM REYLE

In an era often dominated by figural and performance art, Anselm Reyle has focused his career on reinterpreting twentieth-century abstract styles. Using metal foil, acrylic paints, and other materials, he creates a new generation of modernist compositions.

Abstract art has always had its critics. The ironic symbolism of the postmodern age, from Andy Warhol's soup cans to David Hockney's swimming pools, often rejected the somber earnestness of Abstract Expressionism. The simple shapes of the Bauhaus school, as seen in Josef Albers' painted squares, were often parodied as antiquated relics of the fifties and sixties. At the beginning of the twenty-first century, however, many young artists are beginning to re-imagine these "historical" styles. One such artist is Anselm Reyle.

Reyle's work combines the forms of traditional Abstract Art with the sensibilities of the twenty-first century. For example, he eschews oil-based paints for cheaper, shinier materials. Reyle believes his art has "a very psychedelic effect when you look at it from a close distance. A bit like … an acid trip." The artist's most recognizable "paintings" feature vertical, multicolored stripes of foil, acrylic, and glass. They merge the rigorous painting styles of Barnett Newman and Karl Benjamin with the shiny, commercial look of department store gift boxes. Other works, which mix crushed aluminum foil and splashes of paint, resemble the drip paintings of Jackson Pollock or the jagged, abstract landscapes of Clifford Still.

Reyle has also transformed sculptural and conceptual art from the twentieth-century attic. In a series of chrome-covered sculptures, he incorporates the curving, organic shapes of Henry Moore. But while Moore's sculptures were meant to reflect the figural statuary of antiquity, Reyle's glistening creations have a more lugubrious sense of movement—almost like the insides of lava lamps. Other sculptures, such as *Philosophy* (2009), create Op-Art-style illusions on a wall of warped, reflective aluminum shapes. The Minimalist Art of Dan Flavin, with its carefully constructed fluorescent lighting, becomes more chaotic in Reyle's hands. Multicolored neon tubes are twisted into anarchic, scribble-like forms. Even the iconic imagery of

Dadaism and Surrealism are treated to Reyle's humorous touch. Marcel Duchamp's famous *Bicycle Wheel* (1913) introduced the value of using found objects in art. *Reyle's Wagenrad (Wagon Wheel)* (2003) transforms Duchamp's image to an antique-looking wagon wheel, which he places on a wall and backlights with neon illumination. Duchamp's idea may be "antique," but for Reyle it has a continuing influence on modern art.

Reyle's "repackaging" of familiar imagery raises questions as to the nature of art and artistic invention. How can an artist appropriate the work of others and still maintain his or her own originality? What are the distinctions between high art and commodity? Increasing public interest in modern art—and the high prices attained for works by Reyle and other contemporary artists—will make these questions more and more relevant. *bf*

1970 Born in Tübingen, Germany
1997/98 Moves to Berlin, where he founds the Anselm Reyle Atelier
2007 *The Artist's Dining Room*, Tate Modern, London, with Manfred Kuttner and Thomas Scheibitz
2009 *Monochrome Age*, Gagosian Gallery, New York
SINCE 2009 Professor at the University of Fine Arts, Hamburg

left page
Anselm Reyle, *Untitled*, 2010, mixed media on canvas, acrylic glass
143 x 121 x 25 cm, Courtesy Galerie Almine Rech, Paris

above
Anselm Reyle, undated

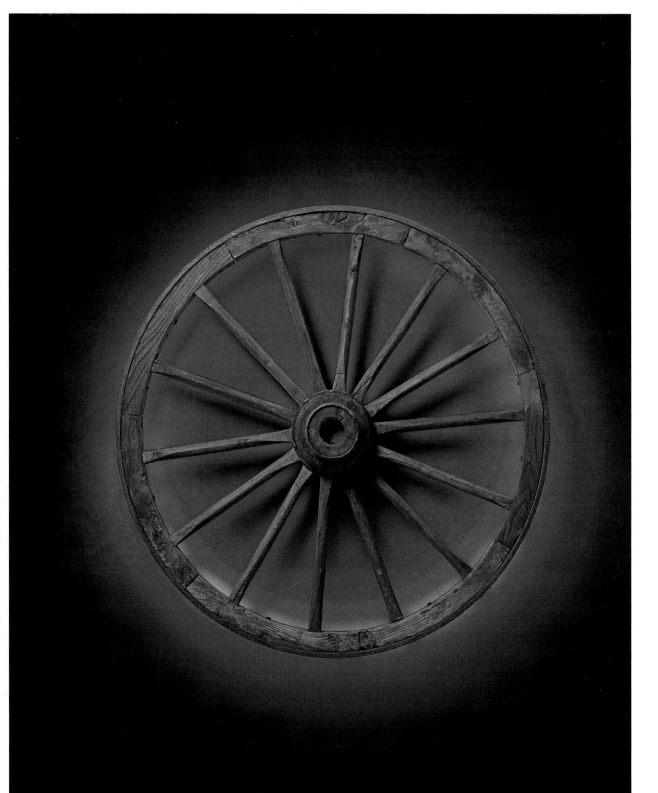

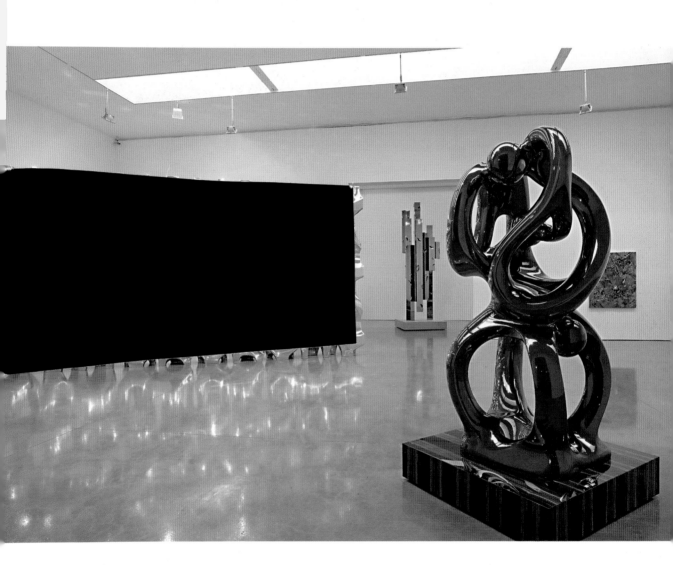

left page
Anselm Reyle, *Wagenrad*, 2009, found
object, LED, 170 x 170 x 45 cm, Courtesy
of the artist

below
Anselm Reyle, exhibition view from the
Monochrome Age exhibition; works:
Eternity, 2009 (front right), *Philosophy*,
2009 (front left), *Untitled*, 2009 (in the
background), Gagosian Gallery,
New York, 2009

1920 1925 1930 1935 1940 1945 1950 1955 1960 1965 1970

Jonathan Meese, "HEY HOTTICHEN:
SCHNULLER DIR DIE SAUKUNST, es
bringt's …", 2010, mixed media,
oil on canvas, 2 parts, 260 x 372 cm,
Courtesy Contemporary Fine Arts, Berlin

1979–89 Soviet-Afghan War

1995 Sweden, Finland, and
Austria join the EU

2006 Musée du Quai Branly opens in Paris

1973 Chilean president Salvador
Allende overthrown

1989 Tiananmen Square massacre
in Beijing

2001 iPod launched

2009 Freighter *Hansa Stavanger* seized by
pirates off the coast of Somalia

1975 1980 1985 1990 1995 2000 2005 2010 2015 2020 2025

JONATHAN MEESE

Meese brings a chaotic sensibility to his art. A consummate performer, his one-man theatrical pieces question the validity of organized religion, rigid political hierarchy, and other forms of social order. His paintings throw together elements from nature, personal history, and pop culture to create an organic stew of color and form.

Jonathan Meese believes in the unique power of art to interpret the past. "Art can deal with the past better than anything else," he has said, "Art makes everything into a toy ... and ... the past has to be a toy of the future. That's the only way to deal with the past." Thus the artist has a responsibility to "play" with the stories and images of the past, providing new ways of understanding their underlying messages—and their role in guiding future decision makers.

Meese's art often plays with themes from his own country's past. Many of his collage-like paintings mix images from German military history with phallic symbols, movie characters, German and English texts, and clipped photographic self-portraits. The total effect of these works can be reminiscent of wall graffiti, an underground protest against a world that hasn't paid enough attention to art. In *Mama Johnny* (2006), Meese places ghostly soldiers on a march toward an unknown war. Above them a golden sun in the shape of an iron cross casts snakelike rays over the men, who hold a battle flag emblazoned with the word "Erz" (Ore). Part of the road is lined with "villagers," who are represented by tiny self-portraits of the artist, while a cartoon-like medieval castle looms in the distance. All of these elements parody the ancient rationales for war—power, treasure, and the "nobility" of national pride.

In *Die Vampirburg "Dark Nackt—Hanswurscht"* (2005), Meese mixes traditional horror tales with religious elements. A vampire's castle looms above a steep cliff—a cliff that also resembles a human face with ominous eyes. Vertical streaks of paint cover the canvas, like falling rain, and Christian crosses surround the castle walls. This expressionist image hearkens back to film sets from *Nosferatu* (1922) and other early Dracula movies, making connections between the fear inspired by horror fiction and the fear of hell inspired by traditional religion. Other Meese paintings use the imagery of pop culture as

art. In *Die Saalhautyng der Mickrigen Realitat (Diktatyr der Kunst de Pypp)* (2008), images of actress Scarlett Johansson's lips and face surround a swirl of painted limbs and genitalia—suggesting the power of commoditized sex in the popular imagination.

Meese produces similarly chaotic imagery in other artistic media. His cast bronze sculptures often resemble giant, mechanized beasts from comic books. In *Totaladler, Baby-Chef der Kunst (das Ei des Columbussy)* (2007), a winged bronze demon seems constructed out of metal plates, cans, and other refuse—the "garbage dump" of its creator's mind. Meese is also famous for his wildly energetic performance art. One of his best-known theatrical works, *Dr. Humpty-Dumpty vs. Fra No-Finger* (2006), was performed at London's Tate Modern. Here Meese thrashed about in a fake boxing ring full of objects. Many of the objects, including plastic heads and a cross with "Richard Wagner" written on it, got tossed and smashed. Meese further escalated the chaos by screaming into a microphone, spitting into the crowd, and hanging from the boxing ropes—an artist physically "exorcising" the demons of the past. *bf*

1970 Born in Tokyo, Japan
1995–98 Studies at the College of Fine
Arts, Hamburg
1997 First solo exhibition *Glocken-
geschrei nach Deutz* in the Galerie
Daniel Buchholz, Cologne
1998 Takes part in the 1st Berlin
Biennale for Contemporary Art
2006 His retrospective *Mama Johnny*
is shown at Deichtorhallen,
Hamburg
2010 *Jonathan Meese: Sculpture*,
Museum of Contemporary Art
Miami

Jonathan Meese, undated